JOHN HEDGECOE'S
POCKET GUIDE
TO VACATION
PHOTOGRAPHY

A Fireside Book
Published by Simon & Schuster Inc.
New York London Toronto Sydney Tokyo

Edited and designed by Mitchell Beazley International Ltd,
Artists House, 14-15 Manette Street, London W1V 5LB

A Fireside Book, published by Simon & Schuster, Inc.
Simon & Schuster Building, Rockefeller Center
1230 Avenue of the Americas, New York, New York 10020

Originally published in Great Britain by Mitchell Beazley Publishers
as JOHN HEDGECOE'S POCKET GUIDE TO TRAVEL
AND HOLIDAY PHOTOGRAPHY

FIRESIDE and colophon are registered trademarks of Simon &
Schuster, Inc.

Typeset and prepared by Hourds Typographica Ltd, Stafford
Origination by Anglia Reproductions Ltd, Witham
Printed and bound in Hong Kong
by Mandarin Offset

Associate author Richard Platt
Executive editor Robert Saxton
Art editor Mike Brown
Production Androulla Pavlou
Artists Paul Williams, David Mallott, Stan North

Acknowledgments
The photograph on page 148 was supplied by Planet Earth Pictures.
The slides and prints shown on pages 156, 157 and 160 belong to
John Garrett and were photographed for Mitchell Beazley by John
Miller. Most of the pictures in this book have been taken on 3M color
film (ISO 100 and 1000).

10 9 8 7 6 5 4 3 2

Library of Congress Cataloging in Publication Data

Hedgecoe, John.
 John Hedgecoe's Pocket Guide to vacation photography.

 "A Fireside book".
 Originally published under title: Pocket guide to
travel and holiday photography.
 Includes index.
 1. Travel photography – Handbooks, manuals, etc.
I. Title. II. Title: Pocket guide to vacation
photography.
TR790.H43 1986 778.9'991 85-27571
ISBN 0-671-62418-0

CONTENTS

CONTENTS

PHOTO BRIEFING

It isn't the camera, the lens, the filter or the flashgun that take successful vacation pictures, it's the photographer behind them. Nevertheless, choosing the right photographic equipment is especially important if you're going to be using it on vacation. There may be no second chances to capture a memorable moment or an eye-catching scene. To some extent, choice of equipment will depend on the type of vacation: a compact camera is ideal if you're traveling light or want to take shots inconspicuously among the locals; but if your interest is wildlife, a better choice would be an SLR with telephoto or zoom. Don't take more than you can carry, or you will soon be discouraged from taking pictures at all. And don't forget the small accessories; by a sun-drenched sea, a polarizing filter may be more useful than an extra lens.

▼ **A wide-angle lens,** with a polarizing filter to darken the sky, enabled me to obtain this dramatic view of a Gaudi building in Barcelona. Because my wide-angle had the same filter size as my 50mm lens, I was able to use the polarizer on both.

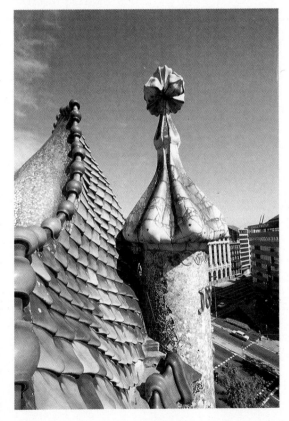

CAMERAS FOR THE TRAVELER

Choosing a camera to take on vacation is a little like choosing clothes for the journey – the ideal is an outfit that is lightweight, easy to carry everywhere you go and as versatile as possible. If saving weight and space are major priorities, a compact autofocus 35mm camera is probably the best choice: it is easy to use and yields excellent pictures. Smaller still, and virtually idiot-proof, though with some sacrifice in image quality, are disc, 126 and 110 cameras. If you are prepared to carry a little extra weight, a 35mm single lens reflex (SLR) camera is unrivaled: it offers greater versatility and has the major advantage of interchangeable lenses. Some seasoned travelers take a compact camera for casual snapshots and an SLR for landscapes, architectural views and other serious picture taking.

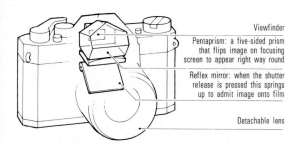

Viewfinder

Pentaprism: a five-sided prism that flips image on focusing screen to appear right way round

Reflex mirror: when the shutter release is pressed this springs up to admit image onto film

Detachable lens

▲ **SLR cameras** have an ingenious optical system that relays the image from the lens to the eyepiece, so that what you see in the viewfinder is exactly what you record on film – whether the subject is a tiny insect or a distant mountain magnified by a zoom lens. Most SLRs today have automatic metering, but with a facility for making exposure adjustments in tricky lighting situations; optional manual control is also usually available. In the automatic mode, the aperture is normally set manually, and the camera sets the shutter speed. However, a programmed camera will set both controls automatically. If you find lights in the viewfinder distracting, choose a needle display, not an LED (light-emitting diode) display. Some SLRs have a depth-of-field preview button, giving you a visual check on depth of field. A few are autofocus.

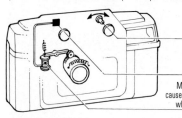

Swiveling infra-red source scans the scene with a pencil-thin beam

Fixed infra-red sensor detects when the infra-red beam hits the subject

Magnet and linkage mechanism cause the lens to spring into focus when the signal is at maximum

▲ **Compact autofocus 35mm** cameras are ideal for grab shots, as they make most of the photo decisions for you. All you do is point the camera and press the shutter release. Details of operating vary from model to model, but most now focus by scanning the subject with a beam of invisible infra-red light. The basic principles are shown in the diagram above: however, you don't need to understand the optics to take pictures. Before you buy, check that the camera has a focus lock control; without this, it will focus correctly only if you keep the subject central in the picture frame. Compacts have a wide-angle lens (35mm or 40mm is common) and often a built-in flash, which pops up for use. Film advance is often motorized.

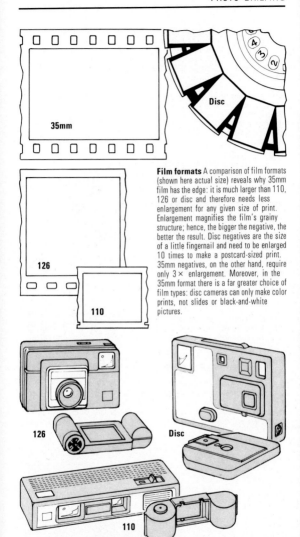

Film formats A comparison of film formats (shown here actual size) reveals why 35mm film has the edge: it is much larger than 110, 126 or disc and therefore needs less enlargement for any given size of print. Enlargement magnifies the film's grainy structure; hence, the bigger the negative, the better the result. Disc negatives are the size of a little fingernail and need to be enlarged 10 times to make a postcard-sized print. 35mm negatives, on the other hand, require only $3 \times$ enlargement. Moreover, in the 35mm format there is a far greater choice of film types: disc cameras can only make color prints, not slides or black-and-white pictures.

▲ **Pocket-sized cameras** are fun to use and virtually foolproof: you can pull one out of your pocket or handbag and snap away in the plane or restaurant. However, don't expect stunning picture quality in comparison with photographs taken with a 35mm camera. The small 110 and disc cameras shown here have built-in flash. Some types have a special switch to change the lens from long-range to close-up subject distances. Thanks to their drop-in film cartridges, these models are all easy to load. Some have a sliding cover which protects the lens. The 126 camera shown here looks a little dated now, and is bulkier than the other two; however, picture quality compares well. One exceptional 110 camera, made by Pentax, takes interchangeable lenses.

7

SLR LENSES/1

Exchanging the standard 50mm lens of an SLR for one of an alternative focal length has an impact that is dramatically obvious as soon as you look in the viewfinder. Telephoto lenses form a magnified view, like a telescope; wide-angle lenses have the opposite effect, making things appear more distant. However, many photographers buy a zoom as their additional lens, instead of another fixed lens. Zooms are heavier than fixed lenses, and may have a smaller maximum aperture, but they offer a wide choice of framing options that more than compensates for these disadvantages. They are becoming increasingly compact; and they are improving rapidly in optical quality, so that their former reputation for being inferior to fixed-focal-length lenses is no longer deserved.

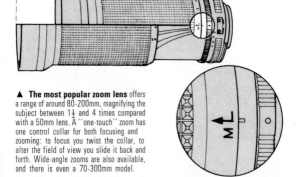

▲ **The most popular zoom lens** offers a range of around 80-200mm, magnifying the subject between 1½ and 4 times compared with a 50mm lens. A "one-touch" zoom has one control collar for both focusing and zooming: to focus you twist the collar, to alter the field of view you slide it back and forth. Wide-angle zooms are also available, and there is even a 70-300mm model.

▼ **Zooms allow you the optimum framing** when there is no time to alter your viewpoint without losing the picture, or when you are shooting from a fixed viewpoint such as the top of a tower. Here, I anticipated the embrace and quickly zoomed to frame the bridge behind.

▲ **A macro control** is a feature of some zoom lenses: this allows you to focus close enough to fill the frame with, typically, a postcard. The macro facility is most useful if it operates with the lens set to its narrowest field of view (that is, its longest focal length).

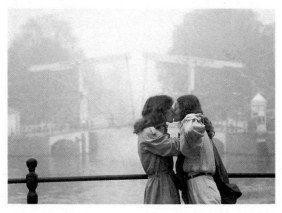

20mm (95°)
28mm (75°)
35mm (63°)

50mm (45°)

105mm (23°)

135mm (16°)

200mm (12°)

Fixed lenses

Manufacturers describe lenses in terms of "focal length". A standard lens normally has a focal length of 50mm and records a scene in roughly the same perspective as the eye sees it. Telephoto lenses, which have a longer focal length and a narrower field of view, are useful for making landscapes look imposing and for photographing people from a discreet distance. Wide-angle lenses, which have a shorter focal length and a wider field of view, take in a broader sweep, and are particularly useful for street scenes, landscapes and interiors. The diagram (left) shows the field of view covered by some of the most popular lenses. Many photographers choose a fixed lens in preference to a zoom: they are lighter and generally less expensive, and gather light more efficiently.

▲ **A teleconverter,** which fits between your camera body and lens, multiplies the lens's focal length (and thus its magnifying power), usually by 1.4× or 2×. These devices are especially useful for the traveler, as they double your framing options without adding much weight to your kit. They can be used with zooms as well as fixed lenses. Below, I used a 2× converter with a 50mm lens.

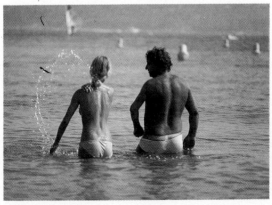

SLR LENSES/2

Despite the versatility of the zoom lens, there are a few tasks for which lenses of fixed focal length are better adapted. For example, a mirror lens is particularly useful on a wildlife safari: it offers a supertelephoto magnification while remaining fairly compact, thanks to a construction based on mirrors which fold the light path. For close-up pictures, many photographers choose a 50mm macro lens; this can also be used at normal subject distances, so it replaces rather than supplements a 50mm standard lens, and thus represents an overall saving in weight. After a 70-200mm zoom, a good choice of lens would be a 28mm wide-angle. However, you might also consider the possibility of a more extreme wide-angle lens (such as 20mm), which offers more exciting perspective effects, and is excellent for photographing in confined interiors and for scenes where you want depth of field to extend from infinity down to a few inches. For architectural photography, a special kind of wide-angle is the shift (or perspective control) lens: this can be moved vertically or sideways in relation to the film, which means that, for example, you can take in the top of a building without having to tilt the camera and thus make vertical lines converge. All these specialized lenses are, of course, relatively expensive but it is possible to make useful savings by buying second-hand.

500mm telephoto lens

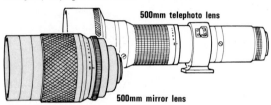

500mm mirror lens

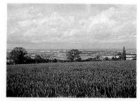

▲ **A mirror lens** is less than half the weight and length of a conventional telephoto of the same focal length, as shown above. I took the landscape below with a 500mm mirror lens; compare a 50mm shot from the same viewpoint (left) to see the advantages. Mirror lenses have a fixed aperture: to adjust exposure you must change the shutter speed or fit a neutral density filter. Use a tripod for maximum sharpness.

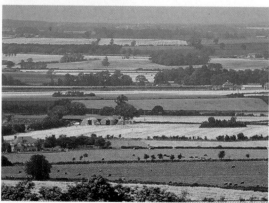

▲ **Wide-angle lenses** can be used simply as a way to distance yourself from a subject. However, by tilting the camera you can also create exciting distortions of perspective, like this one. Wide-angles are unsuitable for close-up portraits: they usually make noses look too big. But you can use them successfully for shots of family and friends provided that you keep your subjects far enough from the camera.

◄ **A 50mm or 55mm macro lens** offers the easiest way to take close-ups, such as the flowerhead picture below. The closest focusing distance will normally be around 9½ inches. With extension tubes added (see page 13), a macro lens can achieve magnifications well beyond life size. However, at extreme magnifications, focusing becomes so critical that you need a tripod to keep the camera position fixed.

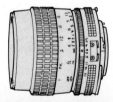

A TRAVEL KIT

In addition to extra lenses, there are various accessories that will enlarge your scope for picture taking or reduce the risk of damage to equipment. The items shown here form a useful all-purpose travel kit, but what you include or leave out will depend partly on your means of transport, the bulk and weight you can handle and the kinds of pictures you intend to take. Items that are indispensable to one photographer may be just useless ballast to another. One essential part of your kit (unless your camera is a compact) is a good-quality camera bag: foam packing inside the bag is a sensible precaution against knocks and bumps. A cleaning kit is also a must.

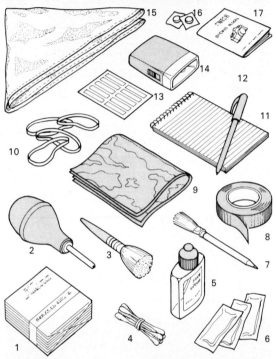

▲ A cleaning kit should contain at least **lens tissues** (1) and a blower or separate **blower and brush** as shown here (2 and 3). **Cotton buds** (4) are good for cleaning hard-to-reach parts of the camera. Also useful are **lens cleaning fluid** (5) — or, as an alternative, ready-moistened **lens wipers** (6). A **typewriter eraser** (7) is ideal for cleaning battery contacts. **Black fabric tape** (8) will conceal shiny parts of the camera when you want to pass unnoticed, and can also be used for attaching filters and many other small tasks. **Plastic bags** (9) are equally versatile. Use them for wrapping lenses, making protective rain hoods and storing exposed film; use **rubber bands** (10) to seal them shut. Take a **notebook** (11) for caption notes. An indelible **spirit marker** (12) will write on film cassettes as well as paper. **Adhesive labels** (13) are also useful to identify exposed film. A **small flashlight** (14) will help you set camera controls at night, and also be handy, placed close to the subject, as a focusing guide in dim light. A foil **space blanket** (15), weighing almost nothing, makes a contrast-reducing reflector in sunlight. Finally, remember to pack **spare camera batteries** (16) and the camera's **instruction book** (17).

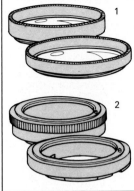

Equipment for close-up photography should be compact and convenient to use. A macro lens is ideal, but costly; it can be used for pictures at normal subject distances. Close-up supplementary lenses (1), used just like filters, are the cheapest alternative and the easiest to use. Two of them – a + 1 and a + 2 should cover most of your requirements. If you have an SLR, you can focus closer by fitting extension tubes (2) between camera body and lens. However, they are more expensive than close-up lenses and trickier to use. When you take pictures by daylight, your camera's TTL meter will compensate for the reduced amount of light reaching the film, but with flash you must calculate the exposure (unless you have TTL flash metering).

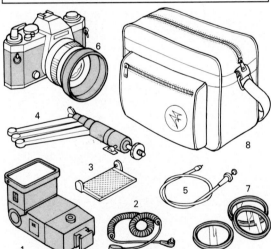

▲ Most of the accessories shown above are more specific to the kind of photography you intend to do than the more general kit illustrated on the opposite page. When buying a **flash unit** (1), consider what you'll use it for: in small rooms with the flash pointed directly at the subject, you can manage with a simple unit; but for bouncing flash off a ceiling to spread the light more evenly you'll need a powerful gun with a tilt head. A **flash extension cable** (2), which costs little more than a roll of film, allows you to move the flash off the camera for more pleasing illumination. Take a **diffuser panel** (3) if you are likely to use the flash with a wide-angle lens. For available-light pictures at night and in dim interiors, pack a **compact tripod** (4) and a **cable release** (5). If you're traveling by car you will probably be able to fit in a full size tripod, which will offer greater stability. A **lens hood** (6) cuts down flare in bright sun. Choice of **filters** (7) is personal but it's a good idea to keep an 81A or 1A filter on every lens at all times as a protection against scratches (see also pages 14-15). Carry equipment in an anonymous-looking **camera bag** (8): this doesn't advertise the fact to potential thieves that you have a camera with you.

13

FILTERS

A judicious selection of filters is a useful addition to any traveling photographer's kit. You can use a filter to add interest to a slightly disappointing view, or to brighten up a dull day. Most valuable of all for everyday use – especially in regions blest with brilliant sunshine – is a polarizing filter. This looks just like a piece of gray glass, but it has dramatic effects: it makes colors richer and cuts down glare and reflections from shiny surfaces. If you take pictures after dark by the light of tungsten lamps, whether indoors or outdoors, you'll find a deep blue 80A filter helpful for removing the distinctive orange cast. Slide film users should equip themselves with a pale yellow 81A filter to remove the blueness that often appears in shots taken on overcast days. For romantic vacation portraits, try using a diffusing filter, which will envelope the subject in a soft-focus haze; for a similar effect, you could smear gel on a UV filter, or attach a piece of gauze over the lens.

▼ **Polarizing filters** darken blue skies – and if there are white clouds in the sky they will stand out more distinctly. The impact is most dramatic when you hold the camera at 90° to the sun. Revolve the filter until you see the desired effect in the viewfinder. Remember, though: a polarizer won't turn a gray sky blue.

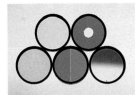

◀ **Filters are inexpensive** – so it's worth buying one or two just as an experiment. The example shown at far left (top row) is a polarizer; the yellow filter below it, for use with black-and-white film, darkens blue skies and increases contrast. The remaining three filters, for color film, selectively color different parts of the frame for special effects, as in the picture shown below.

▲ **Graduated filters** are colored in one half and fade to plain glass in the other. This enables you to tint one half of a photograph while leaving the rest unchanged. A blue graduated filter has colored the sky of this seaside view, giving an effect reminiscent of a hand-tinted postcard. Pale graduated filters are the most useful: brighter colors tend to look garish and unnatural.

▼ **Starburst filters** (also known as cross-screens) have an engraved grid of lines which catch the light, putting a twinkle on every highlight. Use one for sparkling evening seascapes, or other scenes which show the sun's reflection. Shoot at several apertures: stopping down affects the size and sharpness of the star and you cannot easily preview the effect in your viewfinder. Use this filter in moderation.

ANTICIPATING THE WEATHER

Before setting out for unfamiliar places, find out what weather conditions you are likely to encounter. If necessary, consult travel books or climatic records. The conditions you anticipate may affect your choice of equipment to take. Modern cameras and lenses, although generally sturdy, are not designed to withstand extremes of temperature, nor are they anything approaching waterproof. Film is similarly vulnerable, whether or not it has been exposed. But by packing a few extra items, you can minimize the risk of damage. Preparing for the worst conditions will increase your range of picture opportunities, allowing you to venture into the thick of things and bring back striking images – soft color effects in snow showers, subtle contours of a desert in blazing heat, spectacular rainbows before the storm has fully spent its force. Before the trip, read the instructions on these two pages on coping with specific conditions, and use the checklists as a guide to vacation packing.

Heat High temperatures reduce an unexposed film's sensitivity to light, or cause images to deteriorate on exposed film. Films may also show a color shift. Batteries may leak.

Keep film and equipment as cool as possible. Never put films or a camera in the glove compartment of a car, or on the rear shelf: temperatures here can reach 135°F (57°C).

Insulated ice bag

While traveling to your destination, keep film in a suitcase packed among insulating layers of clothing. On photographic expeditions, pack film in a sealed plastic bag inside a well-insulated bag or box; the ice boxes made for picnics are ideal. Wind and rewind slowly to avoid static marks. When removing film from cold storage, allow sufficient warm-up time. Process films as soon as possible after exposure to avoid possible deterioration.

Use white or shiny metal cases for carrying equipment. Or if your camera case is black (and therefore heat-absorbing), keep it covered under a white cloth. White reflective tape on the metal surfaces of camera body and lenses will prevent the surfaces from getting too hot, and in desert conditions will protect equipment from the damaging effect of dust.

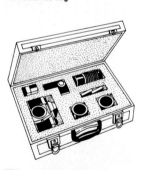

White equipment case

Even in quite moderate heat, haze can be a problem, especially with long-focus lenses. A polarizing filter combats heat most effectively when used at a 90° angle to the sun. Alternatively, use a skylight or UV filter, which will also prevent lenses from being scratched.

A range of lenses – or a zoom – will prevent your having to travel too far in uncomfortable heat in search of the right viewpoint.

Polarizing filters
UV or skylight filters
Shiny camera case
White tape
White cloth
Insulated ice bag
Plastic bags

White tape on camera and lenses

Cold Most equipment works normally down to about 20°F (−7°C). Below this, battery-dependent parts may slow down and the shutter may jam.

Keep the camera tucked inside outer clothing, so that it benefits from body heat. Carry spare batteries. Tape a hand-warming pack to the camera back, or use a pocket battery pack in a warm pocket, connected to your camera by a lead.

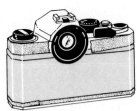

Taped camera with rubber eyepiece

Alternatively, dispense with battery power altogether: instead, use a camera with a mechanical shutter and a handheld selenium-cell meter.

Winding or rewinding quickly may cause film to crack or tear, or create lightning-like static marks. Avoid motordrives; instead, wind on slowly by hand.

A rubber eyecap will keep your eye at a safe distance from freezing metal on the camera. To protect your skin, cover other metal parts with tape.

Pocket battery pack

Silk gloves worn under mittens allow you to remove the mittens for camera-handling without getting your hands too cold.

Spare batteries
Pocket battery pack
Hand-warming pack
Rubber eyecap
Thick adhesive tape
Silk gloves

Rain A UV or skylight filter will protect lenses in light drizzle; wipe off drops with a soft, dry cloth. Keep equipment in a waterproof bag or case until needed. In heavier rain, improvise a rainhood from a plastic bag, as shown in the illustration (right). Place the camera (with lens attached) inside the bag, with the opening at the bottom for your hands. Screw in a lens hood from outside the bag, then cut away the circle of plastic.

Selenium-cell light meter

Waterproof equipment case
Plastic bags
Soft cloth
UV or skylight filters
Lens hood

Humidity In a humid climate, problems include rust, failure of microcircuitry, fungus attacks on lens coatings, and swollen film.

A sealed equipment case is a necessity. Pack it tightly to exclude humid air and surround equipment with packets of moisture-absorbing silica gel. You can dry gel out at intervals in a warm oven or over a fire. In an emergency, you can use rice for the same purpose. Keep films in their sealed canisters until required. Store exposed film in a plastic bag surrounded by silica gel; but squeeze the air out first.

Makeshift rainhood

Sealed equipment case
Silica gel
Plastic bags

Silica gel packets

17

CHOOSING THE FILM

Away from home, the cost of film may be higher than you are used to paying, and choice is often restricted, so it's best to buy what you need before going away. Most vacationers opt for color negative (print) film, as prints, unlike slides, can easily be looked at and passed around in normal lighting. If you wish, you can have extra prints made from the negative, to a choice of different enlargements. Negative film is very tolerant of exposure errors – especially overexposure. However, if you try to underexpose deliberately to create a moody image, you can always expect that the printer will "correct" the effect. Pictures on transparency (or slide) film – also termed "reversal" film – are sharper and have brighter colors than those made on negative film, but to take full advantage of this higher quality you need to be more careful with exposure. Slides look impressive when projected onto a screen, but you can also have prints made from them – although they are more expensive than prints from negatives. Whatever the film type, a crucial decision is the choice of speed – the ISO (formerly known as ASA) rating of the film. The lower the ISO number, the slower the film. The advantages and drawbacks of various speeds are explained below and on the opposite page. Try to have all these factors clear in your mind before you set out.

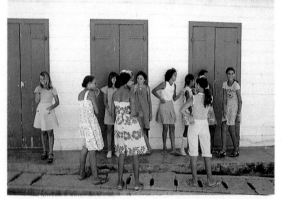

▲ **Slow films** (ISO 25-64) produce the most saturated colors and the finest detail, with relative freedom from grain. However, only slide films are made in such slow speeds, and their low sensitivity to light means that unless you're taking pictures outdoors on a sunny day, you'll need to set wide apertures and slow shutter speeds. Exposure judgments are critical, even to within a half-stop.

▶ **Medium-speed films** (ISO 100-200) are all-purpose films, available in both slide and print form. They are excellent when the weather is changeable, with alternating periods of cloud and sunshine. They give sharp pictures with bright colors, and are sufficiently light-sensitive to enable you to set shutter speeds fast enough to stop movement, even on a dull day. Indoors, however, you'll probably have to use flash.

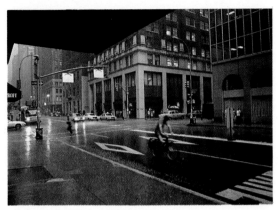

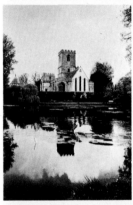

▲ **Fast films** (ISO 200-800) give extra versatility at the expense of more muted colors. Their greater sensitivity to light means that you can use them to take indoor pictures without flash with a handheld camera. Even in dim lighting conditions, such as this rainstorm, you can set a narrow aperture for increased depth of field or a fast shutter speed to freeze action.

◄ **Black-and-white films** perhaps seem anachronistic today, but monochrome pictures make interesting punctuation marks in a vacation album. Moreover, the films are easy to process at home.

▼ **Extra-fast films** (ISO 1000 and above) are useful when the light is too dim for other types — for example, in night clubs. Colors are weak and images tend to be grainy, but this can add atmosphere.

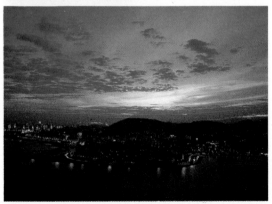

EQUIPMENT CARE

Equipment care should start even before you set off on your trip: in faraway places, camera repairers will be harder to find than at home, and in any case parting with your camera even for just a brief period will probably cause you to miss unrepeatable pictures. So before departure, inspect each piece of equipment and change the batteries for fresh ones. If your camera is new, or hasn't been used for some time, shoot a test roll and have it processed to check that everything is functioning correctly: take some pictures with each lens you own, and some with flash; use all apertures and shutter speed settings. If you do this three or four weeks before departure, you will have time to sort out any problems. While you're away, camera care is largely a matter of commonsense. A light drizzle will do no harm, but keep your camera away from water, sand and blazing heat. Check the meter from time to time, against another camera or a handheld meter. If the electrics fail on an automatic SLR, use the flash setting (1/125) and set the aperture manually.

▼ **Routine maintenance** will eventually become second nature. Follow the instructions below and on the opposite page every time you change a roll. Don't attempt to clean the mirror of an SLR camera, as this is a specialized job. Don't use cheap brushes for cleaning: they will shed hairs, which may get stuck inside the camera.

1 Start with the lens. First, carefully blow off any dust or grit that may have accumulated. This is important, because subsequent steps in the cleaning procedure could drive particles into the lens, causing damage to optical surfaces.

2 Dust specks sometimes cling tenaciously to the lens surface. Remove residual dust with a soft, good-quality brush, brushing in a gentle circular motion starting at the outside edges of the lens and working toward the middle.

3 Fingermarks and spots of grease can be removed with a tissue. Special lens tissue is best, but you can use ordinary tissue paper if necessary. Roll a piece into a tube, tear it in half and use the two torn ends to clean the lens gently.

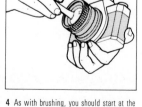

4 As with brushing, you should start at the edges and work inwards. To remove difficult marks, breathe on the glass or use a lens cleaning solvent. Don't use water or household solvent, or you may cause damage.

SLR troubleshooting

If your camera stops working, don't panic; run calmly through the following checks:

● Begin with the obvious: the film may have run out. (Remember that some films have 20 exposures, not 24.) Rewind and reload. If you're in mid-roll, the film may have jammed inside the cassette. To cure this problem, tighten up the film inside the cassette by turning the rewind crank — but don't touch the rewind button or knob.

● Set the camera to manual or to its flash synchronization setting — marked with an X: the suspected jam may be just a long exposure initiated by pressing the shutter release with the lens cap on.

● Crank the film advance lever — it may not have been pushed fully home. Incomplete frame advance often causes the shutter to jam. If you're using a motordrive, remove from the camera and try winding the film by hand.

● Replace the batteries with fresh ones. Alternatively, try cleaning the batteries and camera contacts with a typewriter eraser, if you don't have a replacement set. Double-check that the batteries are the correct way round in the compartment — a common source of error.

● Operate the self-timer control; you may have inadvertently switched this half-way on. If so, operate the shutter using the self-timer to clear the jam.

● Remove the lens. If the lens is jammed onto the camera, it sometimes helps to move the aperture ring to a different setting.

● If the mirror of an SLR camera is locked in the up position, you can sometimes cure the jam by *gently* pulling it down into the viewing position.

● If all these steps fail, get help from a professional photo repairer. Don't use force, and don't attempt amateur repairs.

5 Dust in the viewfinder window does not, of course, affect picture quality, but it can make the focusing screen more difficult to see, particularly when you shoot into the light. Remove dust particles with a cotton bud.

6 Next, open the back of the camera so that you can inspect and clean the film chamber, take-up spool and guide rails. Look out especially for film chips, which can work their way into the film wind mechanism and jam it.

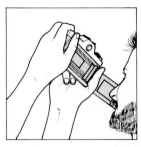

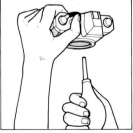

7 With the camera back open, set a small aperture and operate the camera at all shutter speeds while looking at the shutter. The diaphragm should visibly close down, and your ears should tell you if the shutter is working normally.

8 Finally, remove the lens, hold the camera upside down, and blow air into the mirror and the focusing screen to remove dust. Clean the rear element of the lens, but make sure that you don't blow dirt into the lens barrel in the process.

PLANNING THE TRIP

The enjoyment of travel starts with a period of pleasant anticipation: use this time for detailed planning and research. The more you know about the terrain and climate of the area and the type of visual attractions it offers, the easier it will be to choose the right photographic equipment. Approach travel agents and national and regional tourist offices for their free, illustrated literature. This will probably suggest some photogenic sites to which you can plan excursions – and even some places to avoid. For unbiased data about the weather, consult a reference library. An astronomical ephemeris, which gives the times of sunrise and sunset, the angle of the sun at all times of day, and a timetable of tides, is surprisingly useful: picturesque river estuaries can become bleak mudflats at low tide, and it's useful to know when the sun will illuminate a local cathedral facade. Once you have reached your destination, don't hesitate to buttonhole locals for information; it's always sensible to ask several people the same question, as not all the answers you receive will be reliable. Research opening times thoroughly: when you turn up with a tripod to photograph the interior of a church, castle or palace, it's frustrating to discover that it closed at noon. Also, try to discover in advance if photography is in fact allowed, or if special permission has to be obtained, from whom and when.

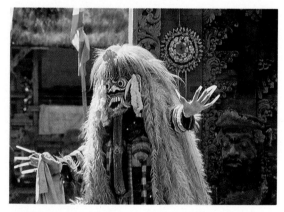

▲ **Festivals** are sometimes on the tourist trail, or even organized specifically for visitors. However, some of the most enjoyable and colorful are attended principally by local people. If your detective work in a library or travel office uncovers a local fiesta, it may be worth rescheduling your travel by a few days to spend a little more time in the area.

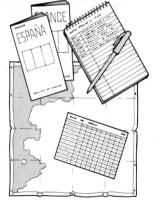

▶ **Maps and timetables** can have long-term benefits for photographers. Buy the largest-scale maps available: they will unlock more local secrets than any guide book. Look at the key carefully: there may be a special symbol for panoramic viewpoints. Timetables help you plan journeys better — perhaps by arranging stop-overs in photogenic spots, or by traveling through duller scenery at night.

PHOTO TECHNIQUES

Modern automatic cameras have freed photographers from a lot of the guesswork, but they cannot guarantee a good picture every time. To build up an effective and varied record of your vacation, you need to master some basic techniques. Try to develop an instinctive familiarity with your camera's controls. If there are settings you have never used, try them out before you go away – they may greatly enlarge your picture opportunities. Don't regard flash purely as a means to light interiors at night: it can produce some interesting results outdoors in bright sunlight. Although some of the techniques described in the following section apply specifically to SLR-owners, there are many others that apply equally well to simpler cameras.

▼ **A change of technique** alters a picture's appearance. To capture this waterfall, I set the shutter to four seconds, knowing that this would show the fall as a silky column. A faster shutter speed would have made the water glass-like. I also knew the camera's meter would be misled by the bright center of the scene, yielding a dark picture; so to prevent this I increased exposure by one stop (see page 30).

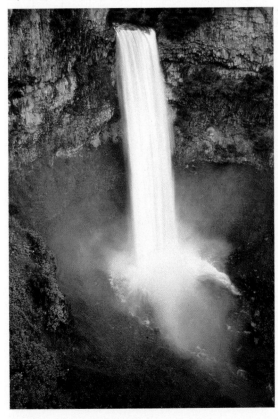

STEADYING THE CAMERA

If your travel pictures look slightly soft, this is not the fault of your lens. The problem is more likely to be camera shake. In extreme form the results of shake are instantly recognizable as streaks across your images. When you handhold the camera, it is difficult to keep your hands absolutely still, but you can eliminate the effects of movement by careful choice of shutter speed. The rule for handholding the camera is never to use a shutter speed slower than the focal length of your lens. Thus you can safely handhold a 28mm lens at 1/30, or a 200mm lens at 1/250. People with steady hands may be able to choose slightly slower settings: it is worth doing a test to check your own limits.

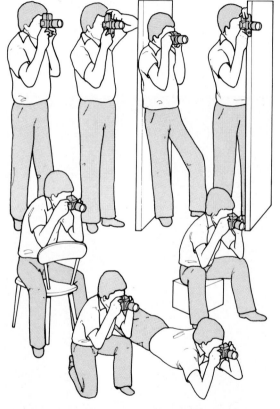

▲ **In a standing position,** keep your feet squarely apart and press your elbows in against your chest. Use your left hand to cradle the lens. It helps to stabilize the camera if you exhale just before taking the picture. If there is extra support available, use it: rest the camera on a wall or fence, or lean back against a building, rockface or the trunk of a tree.

▲ **Sitting, squatting or lying down** can make it easier to steady the camera. Sit astride a chair, resting your elbows on the back; or perched on a stool or steps, use your knees to brace your elbows. Try kneeling, with your elbow on one raised knee. Stretching out full-length on the ground, however, is probably the most stable posture of all.

▶ **A bean bag** is a compact and easily carried device for steadying the camera. You simply rest the bag on any solid surface, such as a wound-down car window, and cushion the camera on top. This approach is especially useful with telephoto or zoom lenses. The bag doesn't have to be literally filled with beans — anything dry and malleable will do. Try rice or sand as substitute fillings. To save weight when traveling, make a bag that can be opened and emptied easily, so that you can carry it empty and fill up at your destination. Make sure that there is no chance of the contents leaking out, especially if using sand, which will quickly grind its way into the camera. If you don't have a purpose-made bean bag, you can improvise by rolling up a coat or scarf.

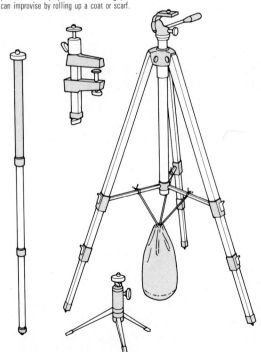

▲ **Camera supports** come in all shapes and sizes — tripods are merely the best known. Generally, the heavier the tripod the more support it gives. But don't choose one so heavy that you have to leave it in your hotel room when venturing out on a photo trip. To steady a lightweight tripod, weight it down with a rock in a bag slung between the legs. Alternatives to tripods are more practical when you are out on foot. Monopods (one-legged tripods) are surprisingly steady, and you can use them to raise the camera above a crowd. Table-top tripods sacrifice steadiness for convenience — choose one with a simple construction and test it at all settings before you buy. Other supports include clamps, ground spikes and wood screws.

WIDENING THE VIEW

Many SLR-owning travel photographers use a wide-angle lens as their standard, instead of a 50mm lens. There is an obvious attraction in this approach. A wide-angle takes in a broader sweep of a landscape or city scene, and allows you to take dramatic shots of buildings in which perspective is exaggerated for deliberate effect. When planning the composition, pay careful attention to the frame edges, not just the central subject. Outdoors, there will usually be a lot of sky in wide-angle shots, and this can mislead the meter, resulting in underexposure. To avoid this, point the camera at the ground when taking an exposure reading.

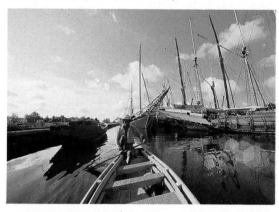

▲ **When you can't move back** for a more distant viewpoint, a wide-angle lens offers the solution. Looking from the stern of this small river craft, a 50mm lens would have shown only the oarsman. However, a 24mm lens allowed me to include the whole scene as I perceived it at the time. To create the sparkling flare spots on the right of the image, I set the lens to its smallest aperture and photographed without a lens hood.

▼ **The extensive depth of field** and distancing effect of a wide-angle lens allow you to include near and far in a single image. To make the effect more spectacular, point the camera down to lower the horizon. Take care that subjects close to the camera, such as this sun worshipper, are clear of the picture corners, or they will be stretched out of shape; the shorter the focal length, the more obvious the distortion.

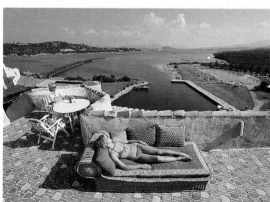

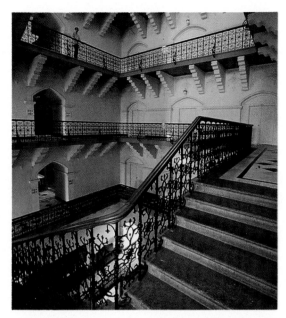

▲ **Photographing interiors** is much easier if you have a wide-angle lens. Stand in one corner of the room to obtain the most comprehensive view. Avoid tilting your camera, or vertical lines will converge or diverge unsettlingly. Wide-angle lenses reduce the effects of camera shake, so in this dimly lit room it was possible to handhold the camera at a shutter speed of just 1/15 without blurring the picture.

▼ **Scenes of bustling activity** benefit from a wide-angle approach, especially if you can find a high viewpoint, such as an upper window or the top of a staircase. Try this method when photographing carnivals, market scenes or local sporting events. For this picture of an African festival, I stood on a lorry to obtain a vantage point. The converging lines of the figures draw the eye to the center.

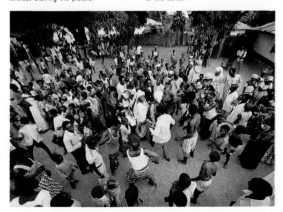

CLOSING IN

It is frustrating when you have no time to explore the full photographic potential of subjects glimpsed in the distance. A telephoto or zoom lens will bring such subjects closer, and will also have other advantages, some of which are illustrated here. When using a long lens, pay special attention to camera steadiness. Choose the fastest speed the light allows, and stabilize the lens if there is a surface to rest it on. Telephotos reduce the depth of field, but this is not a problem when everything in the frame is distant, or when the subject is flat. You can even turn shallow depth of field to advantage, as a way to blur a confusing background.

▶ **Sunsets** look more spectacular in telephoto pictures, simply because the sun looks larger than usual. On slide film or a 35mm negative, the sun will appear about 1mm wide for every 100mm of focal length. However, bear in mind that looking at the sun can damage your eyesight. Never point the camera at it unless its light is considerably weakened: by intervening cloud, by smoke, or by the atmosphere, as at dawn or dusk.

▼ **Compressed perspective** is a hallmark of telephoto shots, although this effect only becomes dramatic at focal lengths of 200mm or longer. Here, two distinct layers of landscape seem flattened and stacked on top of each other, and the clouds are brought forward to make a third dominant layer. The three different tones, becoming paler toward the back of the picture, reinforce the impression of depth.

▲ **Make bold shapes** by setting wide
apertures. At full aperture and focused on a
nearby subject, a telephoto creates an image
whose depth of field is only a few inches, so
that backlit subjects appear like paper
cutouts. To take this picture, I crouched
down and framed the boy against the sky,
setting my 200mm lens at f/4 so that wispy
clouds in the background would be blurred to
the point of invisibility.

▼ **Inaccessible subjects** such as this
hang glider are almost impossible to
photograph satisfactorily without a long lens.
You'll probably find it difficult to "follow
focus" and keep moving subjects sharp. The
best approach is to preset the lens to a
certain distance and press the shutter when
the subject drifts into the narrow band of
sharpness. Use a pan-and-tilt tripod if you
have one.

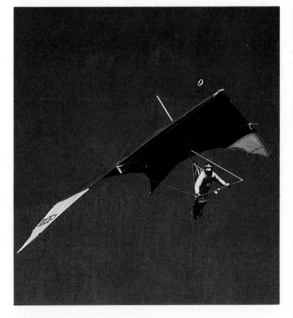

JUDGING EXPOSURE

Almost all modern cameras have an automatic built-in meter of one sort or another. Why then, you might ask, is it necessary for photographers to learn how to judge exposure? The answer is that meters are calibrated to give correct exposure only for average subjects. If you follow a meter's recommendations literally, predominantly light subjects will appear too dark in your pictures, while dark subjects will appear too light: to obtain satisfactory images you need to add or subtract one or two stops to the indicated setting. Learn to recognize situations where such adjustments are called for – the most common are snow scenes, backlit scenes and compositions that include a lot of sky, all of which demand extra exposure. Remember that exposure judgments are more critical with slide film than print film.

▶ **Understand your meter** for consistently correct exposures. Most meters are "center-bottom weighted": they pay most attention to the area just below the center of the frame, as shown here (shaded). If the most important subject is at one side of the frame, move the camera until this area falls over the metering zone, take a reading, transfer this to the camera controls, then re-frame the subject and shoot.

▶ **Exposure adjustments** are easy. Most SLR cameras have an exposure compensation dial like this one. By turning the dial, you can add up to two stops exposure (+2) or stop down by the same amount (−2). If your camera does not have such a dial, you can improvise by altering the ISO setting. To give less exposure, move it to a higher film speed; to give more exposure, move it to a lower film speed.

▼ **Bright sun** creates extreme contrast between highlight and shadow areas, making it impossible to retain a full range of tones and colors in both parts of the scene. One solution is to take a meter reading from the shadows, a second reading from the sunlit areas and split the difference, as I did for this scene. As with all problematic lighting conditions, it is advisable to bracket – that is, to take one picture at the exposure you have calculated, then at least two further pictures at slightly different settings above and below the first setting. Often, this will produce more than one acceptable picture.

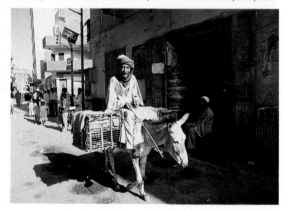

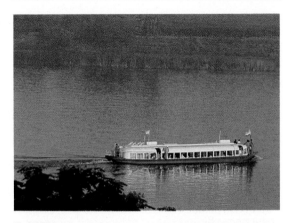

▼ **An 18% gray card** (available from photo dealers) offers a way to obtain an accurate exposure when the subject is light, dark or otherwise difficult. Instead of taking a reading from the subject, take it from the card held close to the subject. If you have no card, aim the meter at your palm, then give ½ stop extra exposure — either set the next slower shutter speed or the next lower f number.

▲ **Average scenes** are those that have approximately equal proportions of dark, light and middle-toned subjects. In this photograph, the river boat is light but quite small — and it is balanced by an area of dark-toned trees. When faced with this scene, most automatic cameras would produce a correct exposure, without any need to resort to the exposure compensation dial.

▼ **Light subjects** such as this white-painted building will come out underexposed unless you carefully interpret the meter reading. To prevent the shed from appearing gray in the final picture, I gave one and a half stops more exposure than the camera's TTL meter indicated, by setting the exposure compensation dial mid-way between the +1 and +2 marking (indicated as ×2 and ×4 on some cameras).

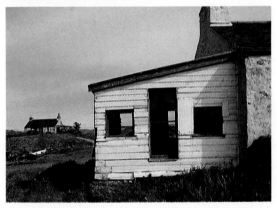

ACTION

You can record action without resorting to complicated techniques or sophisticated equipment: the most important consideration is knowing just when to press the shutter. With good timing you can stop motion even with a simple, non-adjustable camera – either by "panning", to follow a moving subject as you press the shutter; or perhaps by waiting for a peak of action when the subject is momentarily suspended in mid-air. With more sophisticated cameras, such as SLRs, timing is no less crucial: a rapidly moving subject may shoot out of the frame if you're slow to press the button. Focusing is also critical, especially with fast shutter speeds, which demand wide apertures. It often helps to prefocus on a fixed point before your subject reaches it. Don't restrict yourself to conventional views: try a whole range of shutter speeds, not just the fastest on the dial. And if you have flash, try combining flash and daylight, for needle-sharp images with a hint of blur.

▼ **The subject's size** in relation to the picture area helps determine the slowest shutter speed that will freeze the action. Because this canoeist was distanced by a wide-angle lens, I could prevent blur with a speed of 1/125. Had he appeared much larger in the picture, I would have needed a faster speed.

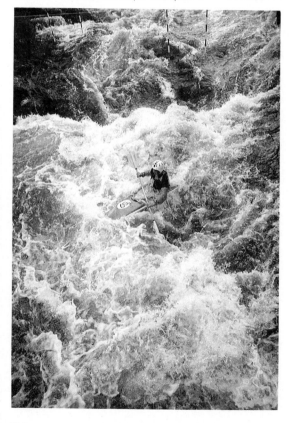

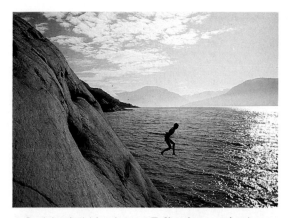

▲ **People jumping** halt for an instant at the peak of their parabola: at this point, even a slow shutter speed will secure sharp pictures. To practice this simple technique, look out for actions that are repeated in a cycle, giving you more than one picture-taking opportunity. This is the approach I took here: this boy was just one of many jumping into the sea. I froze his leap at 1/125.

▼ **Slow shutter speeds** evoke a sense of flowing, continuous movement more vividly than fast speeds. For best results with speeds of 1/15 or slower, choose a light-toned subject moving in front of a darker background. If you want the static parts of the scene to appear sharp, stabilize the camera on a tripod; but if the scene is colorful enough you'll get an arresting result even with a handheld camera.

CREATIVE EXPOSURE CONTROL

"Correct" exposure means giving the film just the right amount of light to record all parts of the subject in tones that correspond as much as possible to what the eye saw. However, you may occasionally decide that a picture will look better if it is made lighter or darker than the reality. To make such creative adjustments, you can use the exposure compensation dial or alter the camera's ISO setting, as described on page 30. Underexposing will yield a "low-key" picture, in which deepened shadows may obscure unwanted detail or add to atmosphere. Overexposure will soften colors and give skin tones a delicate pallor. Attempt such effects with slide films only: with color negative film your interpretations will probably be canceled out during printing.

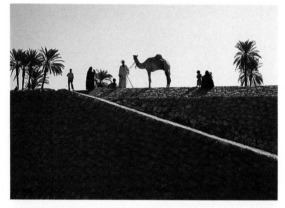

▲ **Bold compositions** with simple outlines often benefit from underexposure. Following a meter reading here would have burned out the sky to white and shown distracting foreground detail. Instead, I underexposed by two stops to emphasize shape. The diagonal highlight looks all the more effective thanks to its dark background.

▼ **Low-key subjects** are those composed mainly of dark tones, but to make a successful low-key picture it isn't enough simply to choose a dark-toned subject. You also need to underexpose by one or two stops, using a gray card or palm reading (see page 31) as a starting point. Here, I used this technique to heighten mood.

▼ **Overexposure** is generally less popular with photographers than underexposure, because it yields pale, washed-out colors with loss of detail in the highlight areas of the picture. However, occasionally it can lead to an attractive pastel effect or convey an impression of blazing heat, and is thus a useful technique for vacations in the sun. Although the correctly exposed image at left accurately records the details and colours of the subject, it fails to conjure up the noonday heat and dust. Creative overexposure led to the more evocative image below, which captures the essence of the scene better than a literal rendering, simply by producing an overall sun-bleached effect. To create this effect I loaded the camera with slide film, set the automatic exposure mode and turned the camera's exposure compensation dial to +2.

COMPOSITION

There are no unbreakable laws about composition: if there were, it would be easy to produce stunning pictures every time. Nevertheless, long before cameras were invented, painters discovered that certain configurations of line and shape work better on the canvas than others – and these compositions work equally well on film. One of the most common mistakes novices make is to exactly center the subject in the frame, making the picture look static. Asymmetrical compositions, like those shown here, are more dynamic. Before you compose the picture in your viewfinder, you need to identify the strongest subject of interest; if this isn't clear to you as you release the shutter, the point of the picture will probably be lost on your viewers. Pick out any other elements that support the main feature, and try to place them so that they contribute balance or drama to the image as a whole.

▼ **Repetition** provides emphasis in photographs, just as it does in speech. In this view of a Greek festival, the women wear the same clothes, hair and smiles, making the composition far stronger than a straight portrait of just one woman would be. Notice, too, how the constant repetition of the women's faces makes the one different face – the little boy – stand out clearly from all the others.

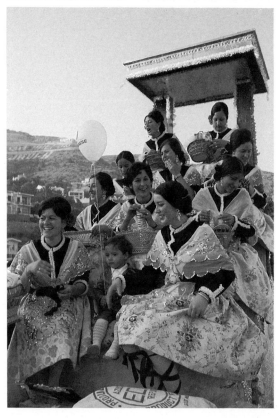

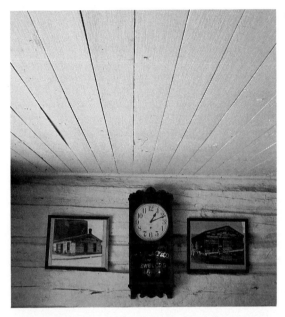

▲ **Lines lead the eye** – so use them to move the viewer's attention from one part of the frame to another. For example, over half this picture is apparently "wasted" on the plain ceiling, yet this area of the scene plays a very important role: the converging lines of the whitewashed boards draw the eye to the principal subject – the clock on the wall. The lines of roads, railway tracks, electric cables, can be used to similar purpose.

▼ **Divide the frame** into thirds for compositions that please the eye. Here, the brightly sunlit step divides the picture frame in the ratio 2:1. Moreover, the group of figures is placed a third of the way into the picture. This division of space is close to what artists call the Golden Section – a theoretically ideal arrangement of shapes that yields perfectly harmonious images and satisfies our sense of proportion.

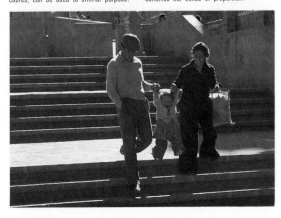

COMPOSING WITH COLOR

Color film adds an extra variable to the equations that govern
composition. Indeed, color can even be a subject in its own right.
Making pictures with vivid, electric hues, like those shown here, is
largely a matter of keeping on the alert for colorful subjects, but there
are several techniques that you can use to intensify the effect. With
slide film, you will find that slight underexposure makes colors
richer: set the film speed dial ⅓ or ½ a stop faster than the nominal
film speed. Slow film – both transparency and negative – always
gives brighter colors than fast film, so when aiming for maximum
color saturation use film with a low ISO number. Finally, you can use
a polarizing filter to make colors more intense. Oriented correctly
over the lens, this filter will absorb the brilliant reflections that dilute
colors when the sun is shining. To discover the angle at which the
colors look their best, revolve the filter while looking through the
viewfinder.

▼ **Color contrasts** make the brightest
pictures of all. Try juxtaposing various
"complementary" colors – those opposite
each other on the color wheel – as I did
with the blue sea and yellow paintwork of
the rowboat in this photograph. I rated the
ISO 64 slide film at 80 to make the hues
even more brilliant.

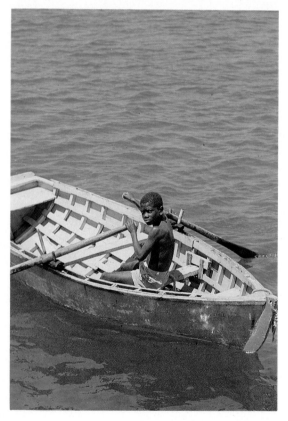

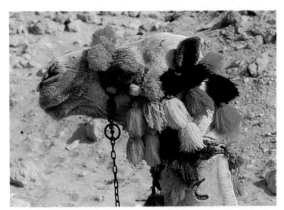

▲ **Neutral backgrounds** make bright colors stand out even more clearly. I was struck not only by the bright tassels which decorated this camel's head, but also by the fact that the animal's coat perfectly matched the sand. I closed in with a 105mm telephoto lens to photograph the creature without disturbing it too much.

▲ **Combining colors** shouldn't be a hit-and-miss affair. This color wheel shows how the spectrum's hues work together. Colors opposite each other contrast most vividly when juxtaposed. Adjacent colors form harmonious combinations.

▼ **Frontal lighting** will bring out color. Casting a shadow across a colorful subject is like adding black to paint on a palette: the color goes dark and muddy. When the sun is low in the sky and directly behind you, all shadows are cast away from the camera and colors are at their richest. So the best times of day for colorful pictures are the early morning and late afternoon. I took this picture about an hour before sunset.

39

USING FRAMES

When you find a photogenic subject, its surroundings should never be treated merely as superfluous details: they always contribute to or detract from the main center of interest, depending on how successfully you arrange the composition. One important way to make the surroundings work for you is to use them as frames to enclose the scene. Arches, doorways and windows make ideal frames, their straight lines or sinuous curves echoing or counterpointing the edges of the picture itself. Natural features, such as foliage, can also serve effectively as frames. You don't need to frame the image on all sides: just at the top and along one side may be enough, as the picture below demonstrates. Whatever frame you use, make sure that it doesn't compete for the viewer's attention with the main subject. Avoid very colorful frames, or those with a lot of busy detail. Often you can tone down an intrusive frame by throwing it out of focus or keeping it in shadow.

▼ **A conflict of scale** between subject and frame can often make an effective basis for a photograph. Here, I dramatized the difference by using a 20mm ultrawide-angle lens. Note how the spiraling foreground leads the eye to the tiny figure. Using foreground frames is a good way to boost contrast on a misty day.

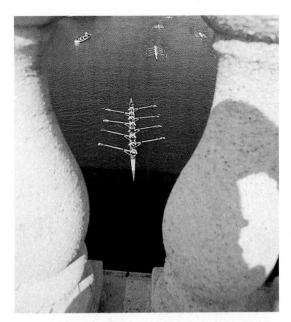

▲ **A symmetrical approach** is sometimes the most effective, especially when one side of the frame perfectly matches the other. Here, the pillars of a bridge form a pleasing urn shape. As I had no telephoto with me, it was impossible to obtain a close-up of the boat crew. Using this balustrade as a frame helped to emphasize the boat in a wide-angle shot; and also had the advantage of disguising other craft.

▼ **Shifting the viewpoint** by just a few inches can make all the difference to a framed picture. Here, I moved my position until the yacht fell neatly between two of the window louvers that divide the picture frame into interesting rectangles. A moderate aperture – f/8 – threw the frame slightly out of focus. The window adds a sense of depth to the picture and helps to relieve a featureless sky.

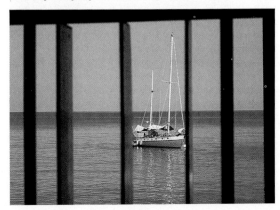

HARMONIZING COLOR

Brilliantly colored subjects cry out to be photographed, and make images with immediate appeal. However, subtler, more muted colors also have an attraction: they yield quieter, more atmospheric pictures that have lasting charm. You can tone down color brightness by using various techniques. For example, deliberately incorrect exposure may help. Underexposing slide film will turn even the most vibrant of hues to earth colors, while giving more exposure than your meter indicates will add white to everything, yielding delicate pastels. Another technique is to use a filter to wash the whole picture with a single color and reduce color contrasts. Colored light has a similar effect to a filter: at the beginning and end of the day the sun's rays are much yellower than at noon, so your images will seem tinged with ocher. Rain, fog, mist and smoke will also reduce the color range of your images. Of course, these approaches will be much more effective if you select pale or single-hued subjects to start with.

▼ **Neglected objects** often acquire a beautiful coloring, thanks to the ruthless onslaughts of weather. In this portrait of an abandoned car, the harmonious hues of rust and dried mud help to evoke a mellow atmosphere.

▲ **White subjects** are the first to pick up color casts as the light changes throughout the day. For creative effects, this can be an asset rather than a problem. This wall in a holiday cottage changed from ocher to a bluish tinge as the morning wore on. For this view, taken a few hours after daybreak, I used a 20 yellow color correction filter to reinforce the yellowish tinge. White walls are common in many parts of the world.

▼ **Lens flare** can work to your advantage in softening the spectrum. To spread the warm color of this sunset across the whole breadth of the image, I removed the skylight filter from my lens, breathed on the front element and replaced the filter. The condensation formed between lens and filter induced an attractive flare. I took several exposures at intervals as the mist gradually cleared.

CHOOSING THE VIEWPOINT

Most of the time, photographers hold their cameras level, obtaining pictures that show the world as our eyes normally see it. However, tilting the camera down or up from a high or low viewpoint gives you a useful way to control the appearance of a photograph. Sometimes even a slight adjustment will make a great improvement – for example, standing on a low wall or at the top of a flight of steps may be sufficient to lift your camera above the crowd for a clearer view of the scene. Kneeling with an uptilted camera will tend to exaggerate the scale of a close-up or middle-distance subject. The examples below and opposite show how extreme viewpoints can create dramatic images that are full of freshness and excitement; to increase the novelty effect, try a wide-angle lens, which will exaggerate perspective. One important advantage of angling the camera sharply is that it can sometimes help you to simplify the background.

▼ **Upward viewpoints** allow you to use a blue sky as a background: this gives more prominence to the main subject and creates dramatic contrasts of color, tone or shape. A polarizing filter will darken a blue sky, whether you have loaded color or black-and-white film in the camera. In this picture, a wide-angle lens exaggerated the converging lines of the composition to convey the exhilaration of sailing.

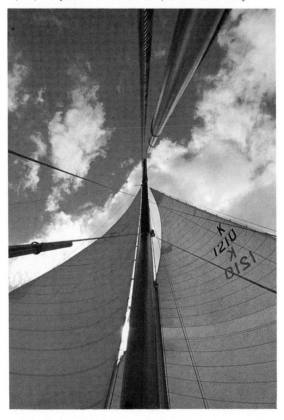

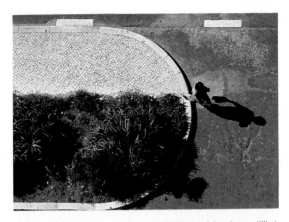

▲ **A hotel balcony** can be an excellent spot from which to take pictures. Don't be put off if your room doesn't look out over an attractive vista: try pointing the camera vertically downward, as I did for this photograph. This way, you can create intriguing semi-abstract pictures, sometimes with graphic patterns. Here, the woman's shadow is a clue that helps us to identify the subject.

▼ **Architectural facades** are difficult to photograph on canal trips or when the street is too narrow for a distant viewpoint. An upward-angled shot captured with a wide-angle may be the solution to this problem. I took this view in Amsterdam. The unnatural perspective emphasizes the towering height of the houses and creates a dynamic pattern out of the windows and other architectural details.

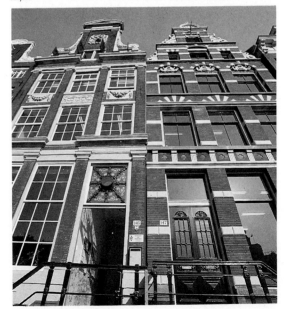

CHOOSING THE TIME OF DAY

As the sun moves across the sky, the orientation and size of shadows change; and so too do the color and brightness of sunlight. There is no optimum time to take photographs, but there is a time to avoid: around noon, the sun casts small shadows vertically downward, and this toplighting flatters few subjects. If possible, take pictures near the beginning and end of the day when a lower sun throws more interesting shadows. At these times, the sun's rays are warmer-toned than at noon so that reds and pinks appear much richer and skin tones healthier. However, if you want perfect color fidelity, fit a blue 82C filter.

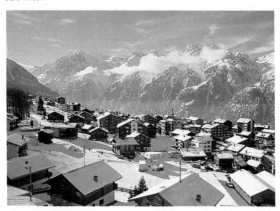

▲ **Mid-afternoon sunlight** suits most subjects: it is brighter and more natural in color than the light just after sunrise or before sunset. Shadows define contours and architectural forms, but without obscuring too much detail. Even with slow film you can set a fast shutter speed to avoid camera shake. These conditions are ideal for a straightforward descriptive view of a subject, such as this alpine village.

▼ **Towards evening,** the light changes rapidly, turning warmly orange at sunset and then an attractive blue. Set up your camera on a tripod or firm surface and shoot a whole roll of film to catch the shifting colors. The contrast of fading daylight and the first glimmers of house lights can give an evocative appearance to villages. I took this shot about eight hours after photographing the view above.

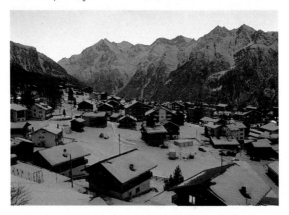

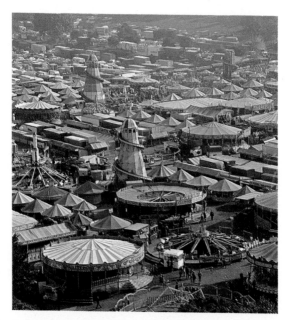

▲ **Early-morning sunlight** has a soft, pearly delicacy that is never quite matched later in the day. Gradually, the gray tones of dawn become tinted with colors, which intensify as the day progresses toward noon. I took this fairground scene just before mid-morning on a spring day. An hour later, the ethereal haze had disappeared, leaving a clear light that was ideal for a series of long telephoto shots.

▼ **Long evening shadows** need to be arranged carefully within the composition. In this view of a Spanish horseman, the shadows of the horse's legs extend all the way to the frame edge, their long horizontals reinforcing the tranquil mood of the image. If I had taken the picture with the sun behind me, my own shadow would have fallen across the field of view and the subtle modeling would have been lost.

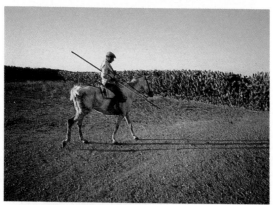

FOREGROUNDS

When photographing a sweeping view, it's often difficult to capture the depth and distance in the scene. One way to achieve this is to organize the composition so that there are at least two distinct subject planes – foreground and background. You need to choose the lens carefully to keep these two elements correctly sized in relation to each other. It is not always necessary to keep both parts of the scene in sharp focus: indeed, a blurred foreground can suggest distance more emphatically than a sharp one – although architectural subjects should not normally be blurred. When the sun is behind you, make sure that your own shadow does not fall into the foreground. Try silhouetting a foreground feature: use your meter to check that the background is at least two stops brighter.

▼ **An architectural foreground** combined with a landscape background is a good way to present two complementary impressions of a place you have visited. Look out for a suitably high viewpoint when taking this approach. For the best results, keep the two halves of the view cleanly separated. In this picture taken in Norway, the diagonal roofline makes a satisfyingly sharp division. Use a telephoto lens to prevent the background from becoming too small in relation to the foreground. Here, I used a 105mm telephoto lens, stopping down to f/16 to keep the foreground sharp.

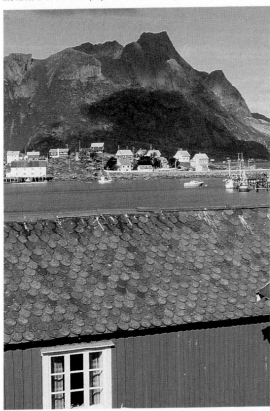

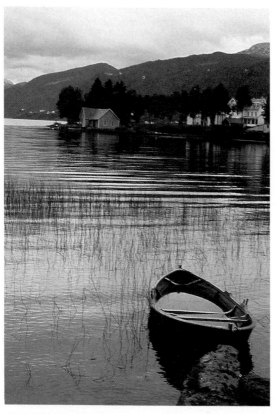

▲ **A man-made object** placed in the foreground can be a useful way to inject additional interest into a landscape. Here, the rowboat enlivens a featureless stretch of water, its prow leading our eyes towards the buildings in the middle distance and suggesting a way to reach them — except that the boat is waterlogged! I took the shot with a 35mm lens, keeping the boat well to the right of the frame to avoid too symmetrical an effect.

◄ **Use echoing shapes** to link the foreground with the background. The similarity in shape between a neatly manicured shrub and the spires of the abbey in the distance suggested this strong composition. A 28mm wide-angle lens enabled me to fit everything in and made a dramatic contrast of scale.

49

INTO THE LIGHT

Point your camera into the light to conceal unwanted details and boost the atmosphere of your images. The best subjects for such contre-jour ("against daylight") pictures are those that have bold, interesting outlines that speak for themselves; stay clear of subjects that rely on our perceptions of detail and color to be recognizable. When shooting into the sun, avoid using a zoom lens: zooms have many glass surfaces, which have the effect of reducing contrast. Remove all filters, clean the front of your lens, then stop down to a small aperture. All these steps will help to cut down flare, making your pictures look crisper and brighter.

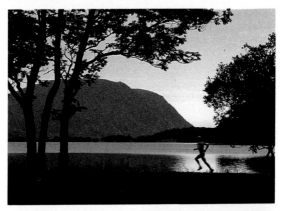

▲ Exposing for the highlights facilitates a faster shutter speed. Here, light reflected off the water allowed 1/250 to freeze the jogger's movement.

▼ Lighting direction totally changes the scene. With the sun behind me (right) these horsemen lacked mystery. Shooting into the sun from a different angle made them more romantic and exciting.

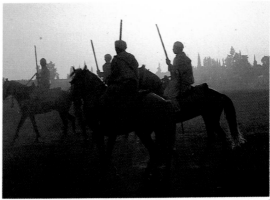

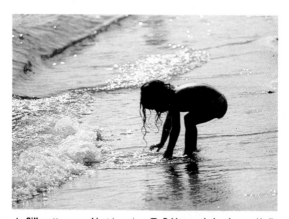

▲ **Silhouette your subject** by setting the exposure to suit the bright background. Simple snapshot cameras do this automatically, but many SLRs have center-weighted meters that ignore the background. With these cameras, take a reading from the highlight areas, then set the camera to manual for the picture — or alternatively use the "exposure memory hold" control if there is one.

▼ **Bridges and churches** are ideally suited to a contre-jour treatment because they are easily recognizable in outline. Reflections on the water carried this colorful sunset right to the shore at my feet. To make the most of the scene, I used a wide-angle lens to fill the foreground with tinted, lapping waves. The camera's automatic meter set the exposure perfectly, although I bracketed to be safe.

AVOIDING CROWDS

Crowds are not a major problem when they are made up of locals, whose day-to-day pursuits provide human interest. However, hordes of tourists detract from the atmosphere – especially at historic sites where bright clothing and conspicuous photographic equipment conflict with the aura of antiquity. Some simple ways to tackle the problem are suggested here. If you have a tripod or other support, an additional technique is to prolong the exposure so that moving figures appear on film as a soft blur, or even disappear altogether. Stop down the aperture and check that the meter indicates an exposure of five seconds or longer; in bright light, you'll probably have to use a neutral density filter, which cuts down the light entering the camera. Film speed falls at exposures longer than one second, so take at least three pictures, giving the meter-indicated exposure for the first, then twice and four times this for subsequent frames.

▼ **Hide ground-level crowds** by pointing the camera upward. This approach may produce an unconventional view, so try to include some characteristic feature in the foreground. The sculpted lion serves this purpose in the picture below, which was taken in Venice. Another effective method is to close in on details.

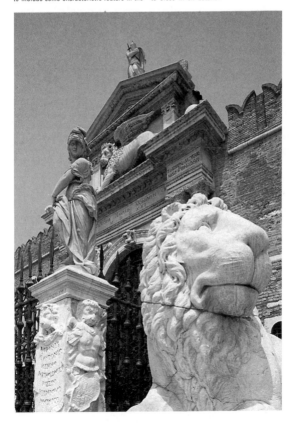

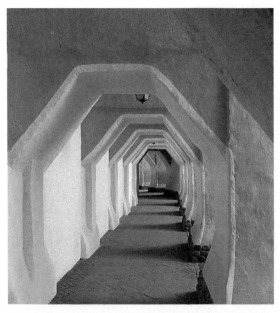

▲ **Even quite large crowds** can be hidden by a careful choice of viewpoint. In this photograph of a monastic cloister, the marching row of pillars restricts the view, and the place looks deserted, despite the fact that people were coming and going all the time. When taking this approach, look out for tourists' shadows, which can wreck a picture just as disastrously as actual figures appearing in the frame.

▼ **Steal a march** on the crowds by arriving at your location early, when your pictures will benefit in atmosphere from the soft morning light. A stroll before breakfast will often yield rewarding images. Later in the day, this popular canalside beauty spot in an English market town soon filled up with trippers, pleasure boats and fishermen, and the clutter persisted well into the early evening.

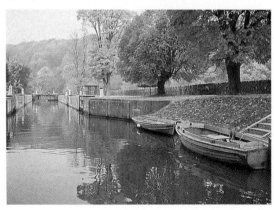

PHOTOGRAPHING IN BRIGHT SUNLIGHT

Sunny weather is holiday weather, but to obtain really good pictures in bright sunlight you may have to adapt your photo technique a little. The sun's brightness allows you to set the fastest shutter speeds for action-stopping pictures of beach games, but beware if you are using fast film: ISO 400 and 1000 films may be overexposed even at the camera's smallest aperture and fastest shutter speed. If you habitually use these fast films, take along a gray neutral density filter: density 0.6 is best – it reduces the speed of the film by two stops, so that ISO 1000 film becomes ISO 250. Alternatively, fit a polarizing filter, which absorbs nearly 70 per cent of the light. Shadows can also be a problem in bright light, especially in portraiture. Either minimize them by photographing your subject in the shade, or else exploit them to make graphic patterns.

▼ **Use slow film** in bright sunlight to capture the minutest detail in a scene. The slowest films give the finest detail of all — their only problem being that when the sun goes in you may have to set unacceptably slow shutter speeds or wide apertures. This Latin American view interested me because of the busy detail in the distance — detail that would have been lost on fast film. Even with ISO 25 slide film, the light was bright enough for me to set 1/125 at f/8 on the camera's controls.

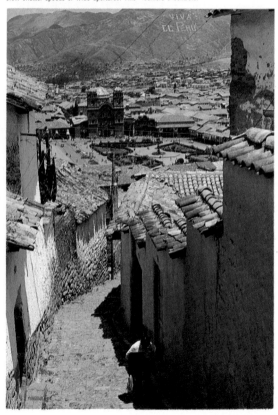

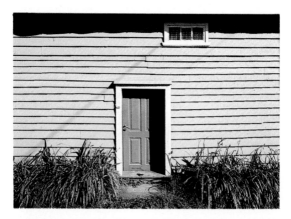

▲ **Shadows** from glancing sunlight define texture and create interesting patterns, but move quite rapidly — they completely obscured this door only half an hour after I took the picture. To intensify the colors in the scene I fitted a polarizing filter, but did not rotate it for maximum effect, as this would have removed the bright reflected highlights from the shiny leaves and detracted from the picture's impact.

▼ **To soften portraits** taken in bright sunlight, turn the camera toward the sun. This throws your subject's face entirely into shadow. Pale sand reflects enough light to illuminate the face, but in darker surroundings you can throw extra light back with an improvised reflector such as a newspaper or white handkerchief. Meter from the face, not the background. A lens hood will reduce flare.

SUGGESTING SCALE

The giant creations of either mankind or nature tend to be particularly memorable to travellers. Architecture on a grand scale shows what can be achieved by people of vision, while gigantic waterfalls, trees or rock formations put human pretensions into a belittling perspective. However, to capture the sense of scale in a photograph, the image must contain some kind of yardstick. An obvious choice is the human figure, although cars, animals and dwellings can also serve this purpose. In close-up pictures you can use a smaller detail, such as a hand. Remember that distance will alter scale relationships: a foreground figure juxtaposed with a vast cathedral half a mile away will tell us little about the monument's size. Keep the main subject and the index of scale at approximately equal distances. To emphasize size, see if you can frame a child somewhere in the picture. Just occasionally, you may want to exclude any indication of scale to deliberately intrigue the viewer.

▼ **Massed detail** helps to convey vastness, especially when the scene stretches as far as the eye can see. For this picture of New York's Fifth Avenue, I used a 300mm lens to pack in as many cars as possible. Summer haze blots out the distant horizon, giving an impression of infinite distance.

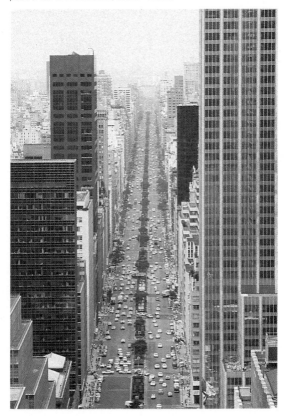

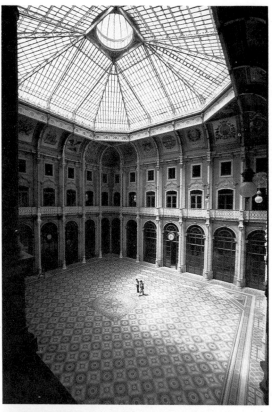

▲ **Distant figures** are best positioned where the eye will immediately notice them. For the picture above I had to act quickly, pressing the shutter release before the pair moved into the shadow area. A 24mm lens stretched the apparent dimensions of the interior.

◀ **Surprises of scale** make eye-catching pictures. Isolated from their surroundings, these playground tubes could be virtually any size; only when we notice the child's face does the whole scene spring into its correct perspective. You can use a similar technique when photographing things in miniature. For example, when taking a view of a model village, make the village as realistic as possible, perhaps with the help of a foliage frame – but then introduce a clue to the real size, such as a prowling cat.

USING FLASH IN DAYLIGHT

In dull weather a flash unit can be used to put sparkle into a person's eyes; while on a sunny day flash is invaluable for lightening dark shadows. Setting exposure is simple. On the film speed dial of the flash unit set double the ISO rating of the film you have loaded. Read off the correct aperture on the unit's calculator dial. Set this on the lens and use the camera's meter to determine the shutter speed. If the camera and flash will not synchronize at this speed, choose a smaller aperture from the calculator, then set a correspondingly slower shutter speed. This approach ensures that daylight remains the dominant light source.

▶ **To highlight the foreground,** you need to let the flash overpower the available daylight. Here, I set the film's true speed on the flashgun's ISO dial, and opted for the smallest of the aperture choices available. Then I took an exposure meter reading from the scene outside the window and chose a shutter speed one stop faster than the meter indicated. As a result, the bowl of fruit dominates the picture; the underexposed background detail is clearly visible but does not compete with the foreground.

▼ **Overcast days** create flat, dull lighting, but flash puts back zest by reflecting off shiny surfaces. Here, this technique adds sparkle to my friend's wet bathing costume and the splashing water. I set the flash's ISO dial to double the speed of the ISO 64 film to preserve a natural-looking effect.

ON THE MOVE

When traveling to your destination, don't keep your camera packed at the bottom of your luggage, or you'll probably miss some of the best images of your trip. While you're on the move, the scenery will change rapidly, unfolding a sequence of photographic possibilities. Be prepared for chance encounters with dramatic landscapes, interesting light effects or scenes of local life. Even if you're traveling by air, you may be able to obtain some fine shots as the plane comes in to land – and en route from the airport to your base you'll undoubtedly want to register first impressions. There's also the chance to photograph fellow passengers. Try to mix candid pictures with posed portraits of travelers with whom you form a brief acquaintance. Most of the photo hints in the following section apply to brief excursions as well as longer trips.

▼ **Photograph the means of travel** to create a lasting reminder of time spent on the move. Wait, however, until you find a good background against which to juxtapose the vehicle. Here, I asked the driver to stop in front of a brooding black mountain.

TRAVELING BY ROAD

In a car you can move at your own pace, stopping to take pictures as you please. Even from a bus you can obtain surprisingly good images through clean windows, provided that the camera doesn't pick up the vehicle's vibrations. The key to photography on the road is to have a loaded camera constantly at hand. For grab shots of people on the street, roadside incidents and other vehicles, keep a short telephoto such as a 105mm lens on the camera – or keep your zoom set to this length. Scenic views don't usually demand quick reactions, but it's useful to have a wide-angle lens accessible in case you see a landscape too good to miss. The view from the road constantly changes as you drive, but the foreground whizzes past more quickly than distant scenery. Exploit this by photographing scenery from several different points along the road, to give a choice of foreground variations on the same basic theme. Similarly, by stopping several times when the road winds among hills, you may have several chances to photograph the same sunset!

▼ **Sum up the journey** with a view of the road ahead. You can use the road to unify a landscape composition. Here, I fitted a 28mm lens to include detail near the camera and emphasize the sense of having many miles yet to travel.

▲ **Including the windshield** in a wide-angle view from inside the car is an effective approach — but don't try this while you're driving! Unless you use flash, it will be impossible to hold detail both inside and out, so meter for the scene outside and record the interior as a silhouetted frame. Clean the glass, or the dirt will show up clearly in your picture — especially if you set a narrow aperture.

▼ **Other road users** can be a rich source of imagery — especially if they react to your presence. To capture this human lorry-load, I pulled over and focused on a mark in the road before the vehicle came too close. I pressed the shutter release just before the vehicle looked sharp in the viewfinder, to allow for the lorry moving closer during the brief time-lag before the shutter opened.

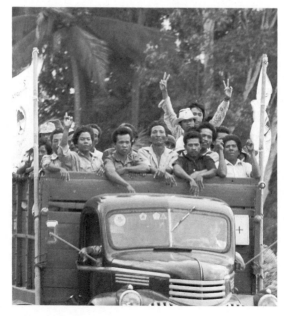

TRAVELING BY AIR

Airlines allow only one small piece of hand luggage, so if you want to keep your camera bag safely in the cabin you must make sure that it doesn't exceed size limitations. As a general guide, check that the total dimensions (length plus breadth plus height) don't exceed 44 inches (110cm). X-rays can spoil undeveloped film, especially fast film, so offer your bag for hand inspection instead. Air photography tends to be most successful just after take-off and before landing: at high altitudes haze and sheer distance will obscure the landscape, although you may be able to obtain good cloud pictures, especially at dawn or dusk.

▲ **The observation platform** of the airport is a good viewpoint for shots of planes landing and taking off. To exaggerate the angle of ascent, simply tilt your camera. Shots such as this make good links in a slide show. Another approach is to set a shutter speed of 1/30 or 1/60 and pan with the plane while it is braking or accelerating along the runway, to blur a confusing background of airport buildings.

▼ **The cockpit** makes an unusual picture that conveys the excitement of air travel: ask the stewardess if you may pay a brief visit. You'll need a wide-angle lens to do justice to the subject. Extreme contrast makes it impossible to record both the sky and the cockpit interior with equal detail, so you must make a choice. Here, I decided to expose for the interior, to give due prominence to the array of instruments.

▲ **On light aircraft,** you have a wider choice of viewpoints — especially if the plane has high wings which leave a clear view of the ground. Focus on infinity and set the lens to maximum aperture: this not only allows the fastest possible shutter speed but also throws any scratches on the window out of focus. Sometimes you may even be able to open a window to take pictures. To minimize vibration, do not rest your elbows or the camera itself on any part of the plane.

◄ **Details of aircraft** are most effective if you choose a close viewpoint and tilt the camera upward against the sky, giving the impression that the plane is mid-flight. In this semi-abstract view of an airliner fuselage and wing, I included the door in one corner of the frame to convey an impression of scale.

63

TRAVELING BY TRAIN

Compared with the brisk efficiency of the airlines, traveling by train is a romantic adventure – particularly if the train is drawn by a panting steam locomotive. Railroad journeys offer a wealth of subjects – not only fellow travelers but also trackside features and the often breathtaking views of the surrounding countryside when the train runs along elevated embankments or viaducts, or snakes around hillsides. For good pictures from a moving train, find a window that opens, as the glass is often dusty on the outside. Use your body to absorb the train's vibrations by standing upright with your legs apart, with the camera held well away from any part of the coach. Fast shutter speeds will freeze all movement of the scene outside, but you may prefer slower speeds to record the foreground trees, fences or telegraph poles as expressive blurs. Including the train's shadow in the foreground can make an effective image.

▼ **Parallel lines** meet at infinity – a phenomenon illustrated by the textbook example of railroad tracks. If possible, crouch low with a wide-angle lens, or alternatively shoot downward from bridges, to exploit this effect. Try to use curves and intersections for their graphic impact, as in this picture. Shiny tracks reflect sunlight, creating brilliant highlights than can help to strengthen the composition.

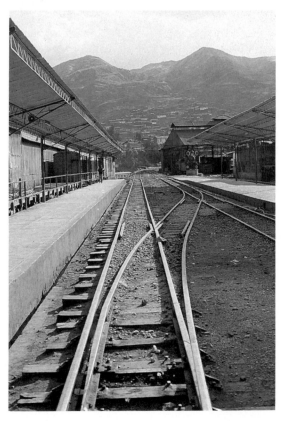

▲ **Step back** from the track for an overall impression. For this view, I walked several hundred yards from the track, and fitted a 200mm lens on a tripod-mounted camera. Only from such a distant viewpoint could I line up the overhead power cables with the weird shapes of the trees lining the tracks. To give the shapes more impact, I printed the picture onto high-contrast paper (grade 4), which yields richer blacks.

▼ **Candid pictures** on trains are easy, because the noise of the train hides the sound of the camera's shutter. Include some of the train itself to put each image in context. Wide-angle lenses are the best choice, as they minimize camera shake: for this shot taken with a medium telephoto I had to wait until the train halted at a station before I could confidently press the shutter release.

TRAVELING BY BOAT

On the open sea, you have plenty of time to explore your ship in search of striking compositions. For example, by fitting a wide-angle lens and tilting the camera upward, you may be able to obtain dramatic shots of the ship's superstructure. Gulls are another good subject: they tend to follow a boat at a fixed distance, making framing and focusing easier. A study of your fellow passengers and uniformed crew may suggest some telling candid pictures. Don't neglect the bustle of activity as the ship is loaded, and then later as passengers disembark. Close in on the boat's wake to suggest movement – the smaller the boat, the more effective this approach will be. On river trips, a zoom lens will usefully extend your framing options for bankside details or shots of other craft.

▼ **Fill the frame** with interest, or your pictures are likely to look empty and dull. In particular, be wary of the expanses of sky or sea that appear when you turn your camera away from the boat. Break up these rectangles of blue by including parts of the vessel in the foreground. Never let the horizon divide the frame exactly in half, or the image will look static. I used all these principles in the picture below, whose asymmetric proportions convey a sense of movement, suggesting that the boat is surging toward the shore ahead. A shutter speed of 1/500 froze the spray.

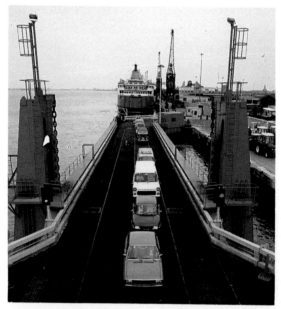

▲ **Dockside images** have an important story-telling function. Arrive early if possible and look around for the best viewpoints. Here, the converging lines of the loading ramp and traffic driving aboard make a dynamic composition and effectively lead the eye to the second ferry boat in the distance. I used an 81B filter to compensate for the cold light of a gray, overcast day. A 35mm lens exaggerated the sense of distance.

▼ **Bright colors** stand out well against a bluish background, especially when enriched by a polarizer. Look out for boats that have recently been repainted, like this Nile sailing boat. If there is enough light in the scene, use slow slide film (such as Kodachrome 25) for maximum color saturation. Reflections will double the area of color, so frame your pictures carefully to include them.

BACKPACKING

If you are carrying a pack on your shoulders, every pound of photographic equipment is an extra burden, so trim your photo kit to the bone. Take a zoom instead of fixed-focal-length lenses. Or consider whether just one telephoto and one wide-angle lens will suffice, leaving your normal lens at home. An ordinary tripod will usually be too heavy and bulky to carry, but a small tabletop tripod is useful. Make sure that you allow enough time for photography on each day's walk: otherwise you'll either find yourself under pressure when taking photographs, or else get left behind by impatient walking companions. For serious photography, a reasonable time allocation in such circumstances is one hour for every five that you would normally allow.

▼ **Rivers** provide clear views in wooded areas; so when you reach them, make the most of the photographic chances they offer before heading on into the trees. A wide-angle lens — here, a 28mm — will take in both the distant hills and the sparkling water at your feet. Although the pleasure of backpacking is to get away from it all, you will sometimes come across the marks of man — for example, a curving dam holding back a reservoir, or a radio mast on a hilltop. Don't necessarily shun such signs of civilization: in the picture below, for example, the bridge helps unify the composition.

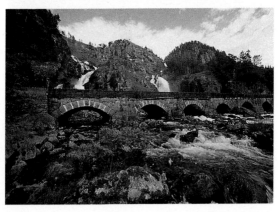

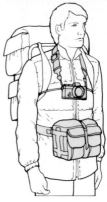

Keep both hands free when walking, but make sure that equipment is readily accessible. A waist bag (above) is useful for film, filters and perhaps an extra lens. If you carry more than this, a climber's photographic bag (right) will rest comfortably on the stomach, counterbalancing a backpack. To stop the camera bouncing as you move, use a chest strap attached to the neck-strap lugs, as shown here.

THE ESSENCE OF PLACE

Pinpointing what it is that gives each place you visit its unique character isn't always easy and catching that special flavor on film is an even greater challenge. It is not enough to include a famous feature or landmark in the picture — such as a gondolier in Venice or the Empire State Building in New York. The secret is to explore each new place with eyes unblinkered by preconceptions, and with your powers of observation attuned to every nuance of atmosphere. Often, the light is the most distinctive feature: watch how it alters the appearance of things as the day progresses. Look out, too, for novelties of architecture, agriculture, transport, dress and other aspects of daily life. Your memories will inevitably be multiple: to ensure that your photos reflect this, mix long shots with details, and vary viewpoints.

▼ **From a distance,** you can show a village in its relation to the landscape around, but without losing characteristic details — here, the palms, church tower and gabled architecture. By choosing a vertical format and restricting the water area to a narrow band, I emphasized the dramatic mountain backdrop.

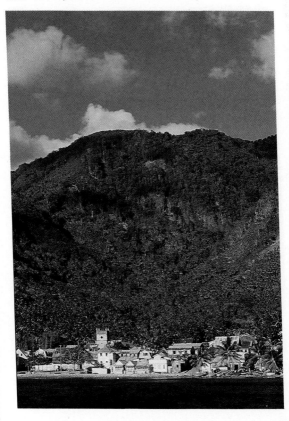

ARCHITECTURE/EXTERIORS

When photographing architecture in bright sunlight, it is important to choose the time of day carefully: large blocks of shadow can spoil a picture, although with care you may be able to build shadows effectively into a composition. Unless you want to create a deliberate special effect, avoid tilting the camera to take in the top of the building, as this will make vertical lines in the structure converge toward the top of the frame. To include the whole building with the camera held level, find an elevated viewpoint. Alternatively, stand well back with a wide-angle lens; this will place the building in the top half of the picture, so make sure that you have a strong foreground. To convey scale, include human figures in the view. Do not neglect out-of-reach details, which you can capture with your zoom or telephoto. Try using one building – perhaps a modern office block – as a background for another in a contrasting style.

▼ **Modern architecture** is suited to an experimental approach. For this shot of the Peach Tree Hotel in Atlanta (Georgia), I pointed the camera upward, and used an 18mm extreme wide-angle lens to stretch the perspective. Frame boldly to emphasize abstract shapes and crisp textures. Try placing an historic building against the grid pattern of a skyscraper, using a telephoto or zoom so that the pattern fills the frame.

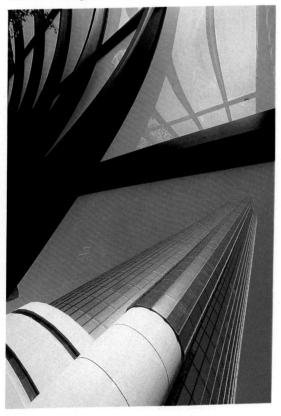

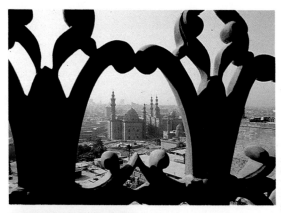

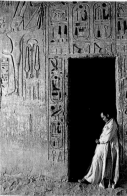

▲ **Framing a building** with a foreground feature conveys distance and adds originality to a much-photographed landmark. Architectural frames, unlike foliage frames, do not look good when blurred, so stop down to increase depth of field, as I did for this effective view of a Cairo mosque.

◄ **Raking sunlight** early or late in the day reveals textures of brick, stone or decorative relief, as in this study of an Egyptian temple. However, overcast light is preferable for more delicate textures. In evening sun, look out for golden reflections in window panes.

▼ **Color** can enliven the most humble domestic architecture. In this New Orleans view, I used a polarizing filter to increase color saturation.

ARCHITECTURE/INTERIORS

Architectural styles vary dramatically from place to place, but this variety is most noticeable indoors, where the architects often let their imaginations run riot. The two main problems when trying to photograph interiors are space and light. To include anything more than a detail of an average-sized room, you will need to use a wide-angle lens – at least 28mm. Even in a vast cathedral a wide-angle gives a better impression of space. The problem of light is not always one of quantity – many modern buildings, at least, are quite brightly lit – but of color. Light sources inside the building are rarely daylight-colored, and even if you use an 80A filter to match the indoor lighting to daylight film, the window areas will still appear an unnatural hue. One solution is to use black-and-white film, as illustrated here. Another is to use color negative film and take care of color balance at the printing stage. Alternatively, use just one light source: either shoot at night or, during the day, make sure that there are no artificial lights to spoil the picture.

▼ **Capture style** by thinking about the architect's intentions. Here the curving banister fascinated me, and I used a 20mm wide-angle lens to fill the frame with its flowing lines. The distant figure adds a dramatic contrast of scale.

▲ **Lighting contrast** is a problem in large daylit rooms. Views such as this require careful metering to preserve detail in both highlight and shadow areas, and it is always advisable to bracket generously. Avoid including large windows in the field of view: the details beyond will inevitably be bleached out, even on a dull day. Remember that some gloom may be appropriate in a historic interior.

▼ **Medium telephoto lenses** can sometimes prove useful in churches and other large buildings where intricate detail is at neck-craning height. Even if you don't have a tripod to allow a slow shutter speed in dim lighting, don't go away without taking a picture. Lean against a pillar (or even lie on your back!) to gain extra stability, or brace yourself against a pew or chair. However, avoid this if there are people worshipping.

CITIES AND TOWNS

The qualities that make each urban settlement unique are not always visual: how do you photograph a Brooklyn accent or the distinctive blend of aromas in a Parisian café? The camera cannot catch such details, but it can convey the essence of a city in other, equally evocative ways. Try capturing the pulse of life by closing in on street scenes. To avoid too chaotic a composition, compose colors carefully within the frame. Skyline panoramas look best if there is a dramatic sky. For skylines uncluttered by a messy foreground, climb to high ground or to the top of a building – or shoot from a park or the edge of a stretch of water. As well as taking wide-angle shots, scan the rooftops with a zoom for details that might look good in close-up, such as TV aerials, chimneys or roof gardens. To capture a quieter mood, take some photographs before the town wakes up: empty streets tend to have an eerie stillness that generally works effectively on film.

▼ **Street signs,** traffic lights and other paraphernalia are an essential part of a city – so don't always try to censor them out of your pictures to create a tidier view. Here, I used traffic lights to balance a portrait of an oddly proportioned New York building, shaped like a giant slice of cheese. The policeman supplies foreground interest.

▲ **Holding the camera** level to keep the verticals parallel will usually mean including a lot of foreground. For a successful shot, you need to make the foreground interesting, or alternatively have a print made in which the bottom area is cropped off. In this Manhattan view, the yellow cab enlivens the street scene and helps to capture the flavor of the city.

▼ **Light trails** from passing cars brighten up the city. Reflective buildings look good when lit by a golden dawn, but on overcast days can seem gray and monolithic. Here, I waited until dusk, set a small aperture and opened the shutter for five seconds to capture red tail lights. I gave one stop more exposure than the meter indicated, as film tends to lose speed in dim light.

VILLAGES

The main characteristic that distinguishes a village from a town is not so much its size as its sense of intimacy. To capture the way that dwellings cluster together, choose a distant viewpoint and include some of the landscape – perhaps with foreground vegetation as a frame. Then move closer and focus on the villagers themselves: their faces are often more welcoming than those of city dwellers. Don't overlook architectural details. You'll find a wide-angle lens useful for fitting in the whole of a cottage in a narrow village street; or with a standard or telephoto lens you can close in on details of hand craftsmanship.

▲ **The unpretentious facades** of village homes make excellent compositions if you frame close. This whitewashed cottage pierced with dark rectangles in northern France seemed like a natural subject for black-and-white film. I was also struck by the sloping floor and by the massive thatched eaves. The occupant neatly framed in the doorway and the scavenging fowl were an unexpected bonus.

▼ **The church** is often the focal point of a village, and commonly has an architectural richness surprising for a small community. The best approach is to stand well back: this not only allows you to take in the tower without tilting the camera, but also allows you to include the surrounding gravestones. Some churchyards have elaborate gateways, which you can use as framing devices. Here I used snow-laden branches to similar effect.

▲ **A view across gardens** or fields sometimes enables you to exclude modern roads from the picture, thus reinforcing the impression of a traditional way of life. Alternatively, choose a time of day when the streets are deserted. The 19th-century novelist Thomas Hardy lived in the cottage above, at Lower Bockhampton, Dorset. Although the garden was open to the public, most visitors confined themselves to the house interior, so it was easy to obtain this view uncluttered by tourists. The shadows and greenery camouflage the dwelling, adding to its atmosphere of being a rural enclave isolated from time.

◀ **Timber architecture** often reveals interesting patterns that cry out for a close-up treatment. A zoom lens will help you to get the optimum framing without having to change your viewpoint.

THE CITY AT NIGHT

Many cities are schizophrenic: quarters that are sleepy by day begin to zing with life when the sun sets, while entertainment areas become throbbing spectacles of neon. To capture such effects on film, you need to take a careful attitude toward exposure. At night, there is a tremendous difference in brightness between light sources and the areas that they illuminate. No film can cope with these extremes of contrast, so you must decide which are the most important parts of the subject and set exposure accordingly. For example, in the image opposite the lights themselves are the focus of interest, so the fact that inky black shadows obscure other details is not a problem. High contrast makes metering tricky. With slide film, bracket two stops either way. To retain shadow detail on color negative film, allow two stops extra exposure. Slow film gives best results, but will usually demand the use of a tripod or other support.

▼ **Photograph at dusk** to retain some color in the sky. Delicate twilight effects fade fast, so you will need to act quickly. Take your shots while the sky is dark enough to show up the brilliance of artificial lights but still light enough to reveal the outlines of buildings and even some of the architectural detail, as in this telephoto view of the Chrysler Building, New York, taken from a neighboring rooftop.

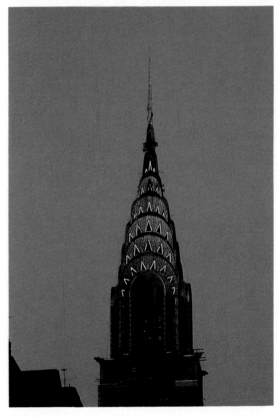

▲ **Experiment freely** to obtain interesting and original effects. For this image of lights festooned along a seaside promenade, I set the shutter speed at one second and made six pictures at different apertures, picking the most colorful one after processing. Half-way through each handheld exposure I jerked the camera upward, so that the brightest lamps formed streaks of light.

▼ **The mood of night scenes** in towns or cities will be affected by film choice. Daylight slide film gives incandescent lights a warm orange glow, but instead you can use special tungsten film, to render the lights naturally and deepen the blue of twilit skies. With daylight film, you can obtain the same effect as with tungsten film by fitting an 80A filter, as I did for this Venetian panorama of diners and canal craft.

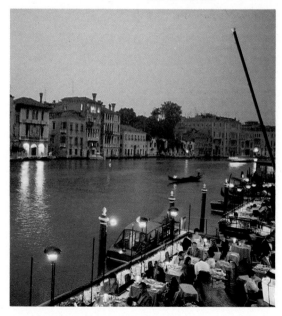

MUSEUMS

Photography isn't always permitted in museums, so ask before you use your camera; even where picture-taking is acceptable, there are often prohibitions against using flash or tripods. However, for most pictures you shouldn't need to use either. Modern museums are usually well lit (with the exception of rooms housing prints and watercolors, which are prone to fading in bright light), and even medium-speed film will cope with typical lighting levels. Paintings and drawings are difficult to photograph properly, and rather than waste film making mediocre copies of your favourite pieces, it's probably better to buy professionally-taken slides from the museum bookstore. Sculpture offers more scope, with plenty of room for creative experiment: try a variety of camera angles, and close in on details and textures. Remember that the best museum subjects of all may be the buildings, and the people, rather than the exhibits.

▼ **Uncluttered layouts,** with fewer pieces better displayed, are the modern style – which makes life much easier for the photographer. To convey the spaciousness of this converted palm house, I fitted a 28mm lens, tilting the camera slightly upward to take in the patterned glass roof. An extra half-stop exposure has made the interior seem more airy. Black-and-white film has removed distracting color accents from the scene.

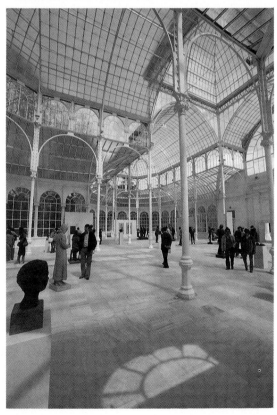

▲ **Sculpture** is often displayed in museum gardens or courtyards, where there are no exposure or filtration problems. Diffused sunlight gives best results with figurative sculpture, although abstract sculpture may look more dramatic when bright sun casts dark shadows. This statue's bizarre expression was enhanced by a wide-angle close-up view, which distorted the features.

▼ **Focus on people** to bring museum or gallery scenes to life. However interesting porcelain or Picasso may be to you, others may not share your enthusiasm. By including a figure, you will instantly catch your viewer's attention. Look for people who get thoroughly absorbed: the juxtaposition of visitors and exhibits can make an amusing comment on how people relate to art. Use a wide-angle lens to portray the surroundings effectively.

FAMOUS SITES

Photographing a well-known building in an interesting way is a challenge to your creativity. A glance at a postcard rack will reveal how other photographers have depicted the place: you will then know the clichés to avoid. Emphasize the aspects that make the strongest impression on you. Look for unusual viewpoints: if everyone else photographs the spot from ground level, try looking downward from a neighbouring building. Don't just take pictures on a sunny day – go back in the rain or at dawn. Floodlighting of buildings at night can provide spectacular pictures. To intensify the atmosphere of a romantic castle or ruin, use a tripod and experiment with long exposures at dusk.

▲ **Strong shapes,** such as domes or spires, benefit from silhouetting. This approach is especially effective when the outline immediately identifies the building – or at least its location or style, as was the case with this Islamic tomb in India. If I had given more exposure to show detail in this building, the sky would have bleached out to white.

▼ **When closing in,** look for contrasts of texture or shape. In this view of a giant suspension bridge, a low viewpoint accentuates the contrast of web-like wires and solid masonry. Another advantage of the tilted camera angle is that it excludes traffic. I used a 300mm lens on a tripod-mounted camera from a convenient vantage point on the river bank.

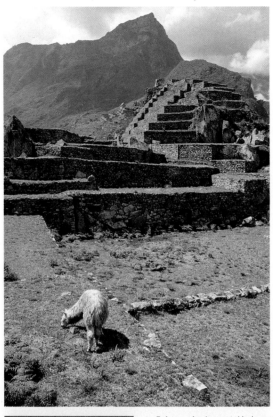

▲ **Ruins** are often best treated in the way that you would approach a landscape. Frame generously to show how the site blends with the surrounding countryside. For this shot of the Inca settlement of Machu Picchu, I chose a viewpoint that shows the stepped temple juxtaposed with echoing shapes in the hills behind. The llama adds life to the image, and distinguishes it from conventional postcard views.

◄ **Towers** tend to be difficult to isolate from their surroundings. You can tilt your camera upward or choose a high viewpoint, but this will often make a uniform sky too dominant. Here, I solved this problem and created an unusual image by framing a traffic signal in the foreground of a view of London's Big Ben clocktower. A ten-second exposure caught all three lights in one image.

COMPOSING A LANDSCAPE

Most amateur photographers compose a landscape by trying to squeeze in as much of the scene as they see in front of them. However, this approach usually yields disappointing results: the camera records much less than our eyes can see, so the sense of an exhilarating panorama is lost. Moreover, the details that enchant the eye come out small and insignificant on film. A better strategy is to analyze what aspect of the landscape interests you most and make this the main focus of the composition. In the picture below I was struck by the similar shapes of mountain and rock, and organized the composition to reveal this visual echo. The center of interest need not hold our attention by virtue of its size: even small elements can draw the eye if judiciously placed. Avoid placing the horizon in the center. If the sky is interesting, you can afford to give it plenty of space; otherwise, limit it to a narrow band or exclude it altogether.

▼ **An upright format** is unusual for a landscape picture, and makes an impact simply because it's different. Vertical pictures also provide a better impression of depth, because nearby detail is juxtaposed with the scene in the distance. Try to find a foreground feature to hold the attention and anchor the image. I exaggerated the proportions of this rock by using a 24mm wide-angle lens.

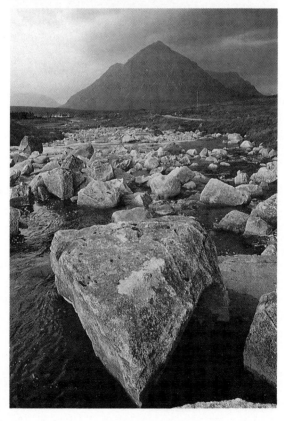

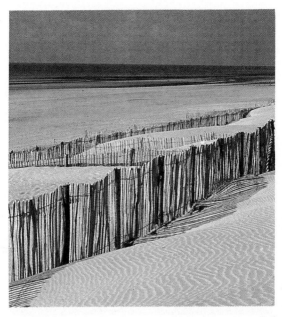

▲ **Suggest depth** by including similar elements at increasing distances from the camera. We assume that the posts of these seaside windbreaks are equal in height, so they serve as useful yardsticks for judging distance. Trees, field boundaries and farm buildings can be used to comparable effect. Notice how the zigagging lines lead the eye around the picture and tie the composition together.

▼ **Small details** catch the eye readily if the rest of the frame is dominated by large plain areas, or by regular patterns. Tonal differences also stand out: our attention is magnetized by the white highlight at the top left of this picture. I carefully placed the figure and his house at equal distances from the frame edges, so that the viewer would equate the two: farmer and horse on the right, home on the left.

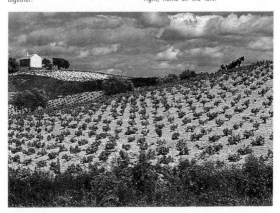

LANDSCAPE AND THE SEASONS

Seasonal change transfigures a landscape, not only through the obvious effects of snow or the presence or absence of leaves but also because of the different qualities of light. In summer, noon sun streams almost vertically downward; but in winter, in many regions, the sun barely manages to creep above the horizon, and shadows are long and indistinct. So it's often worth making a detour to revisit a place you've photographed before at a different time of year – you may come away with a completely fresh view. To capture the subtleties of seasonal light effects, many photographers prefer to use slide film rather than print film, although this requires careful exposure judgments.

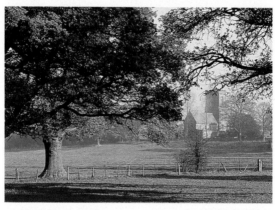

▲ **Oblique autumn light** reveals the texture of landscapes, but without causing excessive contrasts of light and shade within the picture. In this typically autumnal view, the gauzy haze gives a powerful impression of depth, while the weak sunlight is enough to bring out the gold hues of the leaves. Lighting levels are often low, so it is advisable to use medium-speed film.

▼ **Misty spring mornings** make serene pictures, but you need to rise early, as mist soon clears. It lingers longer, though, in hollows and over water, so I headed for the river to catch this quiet view. I gave one stop extra exposure to the reading the meter indicated to make the scene ethereal and high-key. ISO 100 slide film captured the delicate nuances of color.

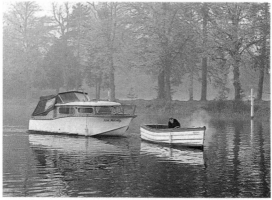

▲ **Wintry, overcast skies** tend to make landscapes flat and formless, but you can overcome this problem with strong composition. This lone tree stood out like an engraving against the steel-blue sky. When I looked through the lens, the image still seemed somewhat lifeless. However, the chance element of birds flying past completed the winter scene, adding greatly to the atmosphere.

▼ **Cloud** can make a major contribution to the atmosphere of a landscape. On a windy day, the scene changes minute by minute as clouds skate past, casting shifting shadows on the land beneath. Take a meter reading from the sky to maximize cloud detail; this will usually make the ground area dark and featureless, but when there's snow about you may be able to retain detail in both areas, as in this bleak winter view.

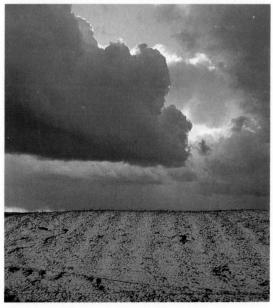

RURAL LANDSCAPES

Much of what we regard as unspoiled countryside bears the imprint of humanity: patterns of fields, hedges and even woodlands are the result of centuries of labor. To make pictures with a strongly rural flavor, try to base your compositions around these signs of cultivation. For example, hay and straw are stacked in many different ways, from the factory farm's huge rolls to the roofed structures of traditional haystacks. Frame such features in the foreground to create graphic images that need no captions or explanations to make their point. Field boundaries and rows of crops help to define the contours of the landscape. Look out, too, for subjects that represent the seasons.

▼ **Buildings in rural landscapes,** far from being ugly blots, often blend in attractively with their surroundings — especially when they are made from local stone. This derelict mill complex, evoking the decay of industry in the valleys of north Yorkshire, England, adds connotations of the past that give an interesting dimension to the image.

▶ **Nature's greens** come in many different shades: see how many you can include in one image. Some films, especially slide films, tend to make greens look blue, but you can correct this imbalance by filtration. I used a 10 yellow color correction filter for this picture taken in Switzerland, but an 81 series filter would have served just as well.

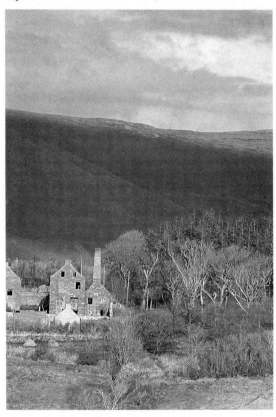

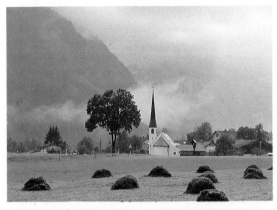

◀ **Large fields** cultivated with a single crop provide good opportunities for images. Use a telephoto to get panels of different colors butted up against each other. Areas of yellow, like this field of oilseed rape, are easily muddied by underexposure, so it is sensible to bracket your pictures. For this view, I bracketed at half-stop, not full-stop, intervals to be sure of a good result. An 81B filter warmed up the color.

▼ **Animals** can breathe life into subtle monochrome landscapes like this tranquil river view, photographed in the heart of rural France. An exposure meter reading taken from the surface of the water ensured that the cows and duck would appear as silhouettes outlined against the mist and the gently rippling water.

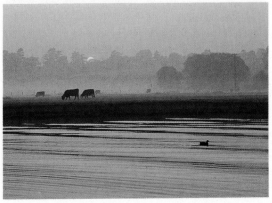

MOUNTAIN LANDSCAPES

The grandeur of mountain scenery can be difficult to convey in a photograph. But fortunately, the best viewpoint is not necessarily the highest summit. A vantage-point lower down, in a valley or on the foothills, will enable you to juxtapose distant rugged peaks with foreground features of a quite different character – such as meadows dotted with cows or a foreground frame of foliage. If you do decide to shoot at higher altitudes, check whether there is a cable car, chair lift or mountain railroad in the area. This will not only take you painlessly to the summit but will also offer picture chances en route. As you go higher, haze will become a problem, but you can sometimes clear the view with filtration. Try a straw-colored 81 series filter to reduce the excessive blueness that haze produces. A polarizer may help, but only at certain angles to the sun. A good time to take pictures is early morning or late afternoon, when low sunlight casts interesting shadows as it rakes across rock or snow.

▼ **The weather** over mountains tends to change quickly, with complex cloud movements. Watch for the sun breaking through, as it did here to illuminate a roadside clump of grass, which contrasts dramatically with the snow-clad peak. By excluding the road from the foreground I gave the impression of a wild landscape.

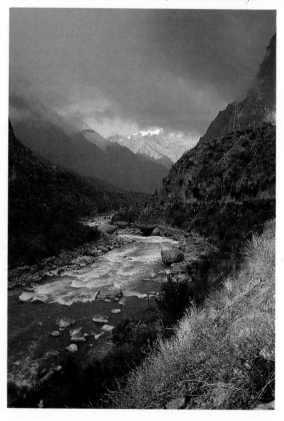

▲ **Aerial perspective** is the effect of distance in a picture caused by atmospheric haze, which makes peaks at increasing distances look lighter and bluer. You can exaggerate the effect by using a telephoto lens (or a zoom at its longest settings) and by choosing views that contain a succession of ridges and valleys stacked one behind the other, as in the picture above, taken with a 200mm lens on a tripod-mounted camera.

▼ **When climbing** to a high viewpoint in search of panoramas like this one, there are a number of precautions to take. Thin mountain air causes shortage of breath after only mild exertion, making you vulnerable to camera shake: ensure you have fully recovered your breath before shooting. On arduous climbs, protect your equipment in a photographic hip bag, which leaves arms and shoulders free.

FORESTS AND WOODLANDS

Travel will often bring you into contact with different kinds of
woodland, whose appearance will vary according to climate,
altitude and soil type. In a fresh landscape, you will probably have
the chance to photograph not only new species of trees but also new
growth patterns. If the trees are deciduous, your precise approach
will depend on the season. In spring and summer, it helps to use a
polarizer when you photograph sunlit foliage: this filter cuts down
reflections from leaves and makes them appear lusher and greener. A
canopy of leaves will throw a green color cast onto any pale-colored
subjects that share the picture area – for example, a white woodland
cottage or white flowers on the forest floor – but you can remove this
cast by fitting a 10 or 20 red color correction filter. In autumn, a
yellow or 81 series filter will enrich the golden hues of nature. Woods
are complex environments that benefit from strong composition: try
including some feature such as a lightning-stricken tree or a
foreground stream to structure the image.

▼ **Look up** at the tree tops to exclude the
jumble of undergrowth, isolate a tree from its
neighbours or create effective patterns
against a plain background. Here, spiky
leaves stand out against a sky darkened by a
polarizing filter.

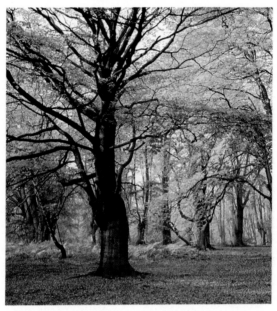

▲ **Autumn colors** have a peak of brilliance which may last only a fortnight or so — some years the famous New England fall is at its most photogenic for just a matter of days. In areas renowned for autumn colors, local newspapers advise on the best dates to visit, and often include route maps that take in the best views. Check these details before setting out with your camera. Capture color changes in the foliage over a period of time.

▼ **Leafless trees** have as much photographic potential as summer foliage. And in winter you can see further through the woods because the view is less obstructed. When snow falls, don't take the obvious step of using black-and-white film: the hues of a snowy wood are very subtle, but are well worth recording. In this picture I used the path and the distant figure to anchor the composition.

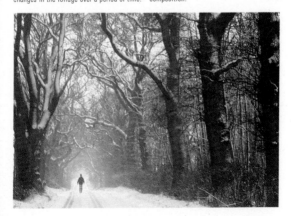

EVENING LANDSCAPES

The French have a romantic phrase for the interlude when the sun has set but night not yet begun: "entre le chien et le loup" (literally, "between the dog and the wolf"). For the landscape photographer this brief period has a special appeal. To capture subtle evening colors, take a meter reading from the sky area, but avoiding the setting sun or the bright glow that marks its passage over the horizon. If you can, include a lake or river in the scene to spread the light. Pictures that show the moon are most effective when the sky itself is still relatively light and when the moon is at least half-full; use a long lens.

▲ **Silhouetting** the landscape is a good way to make even a spoilt or uninspiring stretch of countryside seem attractive. Here, our impression is of woodland or parkland, but there were also some untidy shacks in the field of view, obscured by following a meter reading for the dramatic sky. A 20mm wide-angle lens brought the whole of the spectacular cloud formation into the picture frame.

▼ **Skyscapes** become dramatic at evening. Even if the sky has been overcast all day, the clouds often break to yield excellent picture chances. For this picture, I pointed the camera up to catch the silver halo thrown by an obscured sun. A light breeze was moving the clouds along, so I had to act quickly. I took two meter readings, one from the halo and one from the sky area around the cloud, and averaged the results.

▲ **Traffic trails** show up only when the sun is well over the horizon — but by then it may be too dark to record detail in other areas. A double exposure solves the problem: mount the camera on a tripod and make the first exposure at twilight, underexposing by one stop. Retension the shutter by cranking the film wind with the rewind button pressed in. Then wait until dark before making the second exposure to capture the car lights.

▼ **At dusk,** the temptation to photograph the sun itself is often irresistible; but once you've done this, turn around and look at the way the fading light tints the scenery. If you want to preserve some detail in the scene, add one or one-and-a-half stops more exposure than the meter indicates when aimed at the sky. In this view of a Welsh chapel, the snow reflects the beautiful orange light of the evening.

SNOWSCAPES

Snow can add a dramatic new dimension to your landscape pictures. A white snow blanket will highlight certain aspects of the scenery and conceal others, in quite unpredictable and quirky ways. It is surprising how the view changes after a snowstorm. Remember to add one or two stops to your meter reading to compensate for the dazzling light reflected off white surfaces (or with an automatic camera, set a slower film speed on your camera's ISO dial). Some regions that are snow-covered for many months of the year have evolved their own style of steep-roofed timbered architecture: settlements in this style make picturesque subjects, especially when they nestle among mountains. In bitter cold, protect equipment and film by taking the precautions given on page 17.

▼ **Make patterns** from the snow by tight framing and careful choice of viewpoint. I took this picture from an aircraft, but less extreme viewpoints, such as hilltops, provide equally good opportunities. Fit a telephoto lens and crop in on neighboring hillsides. Check the weather conditions before you climb to a high vantage point, or you may find that the view is veiled by cloud or mist. Raking morning and evening sunlight will provide form and modeling, picking out every tree and ditch; but around the middle of the day, and in dull weather, the snow will appear flat and uninteresting.

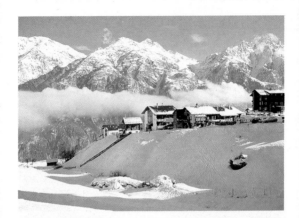

▲ **In sunlight** under a cloudless sky, shadows on snow will pick up a blue color cast, as in this view of an Alpine village. Usually, there is no need to use a filter to compensate — the blueness looks quite natural. However, if shadows fill the entire picture, fit an 81EF filter to eliminate the cast. Another useful accessory for snow scenes is a polarizing filter to eliminate glare from your picture.

▼ **Muted colors** are one of the great advantages of a snowfall. By suppressing color, you can concentrate attention on textures and shapes. Here I used a 28mm wide-angle lens to juxtapose the busy pattern of the foreground grasses with the branching shape of the lone tree. There are hues in the scene, but they are extremely delicate: the picture is a symphony in gray. I used a 28mm lens, with Ektachrome 200 film.

SEASIDE RESORTS

In vacation brochures, you'll see the same kinds of stereotyped images repeated over and over, with generous supplies of sand, sea, sun and swimsuits. However, seaside resorts have many other aspects worthy of the photographer's attention. Although the beach is the main focus of activity, the true flavor of the place may be better sought at the harbor, the pier or even a tattered row of hotels along the promenade. Explore the whole area, not just places where crowds congregate. And when bad weather drives everyone indoors, venture out to capture the change of mood: there will usually be a few other hardy lingerers to add human interest.

▲ **Evening sun** can make a dramatic difference to beach shots, even in east coast resorts when the sunset is on the inland side. I took this picture just after a storm, aiming the camera toward the re-emerging sun to backlight the spray and to catch bright highlights on the sea as it retreated down the beach. Monochromatic color adds to the picture's subtle atmosphere. I used ISO 100 slide film in a compact camera.

▼ **On a gray day,** look for something that will put color into the foregound. Warm colors, such as these bright fishing floats, work best: reds and oranges seem to advance toward the viewer, contributing to the image a powerful sense of depth. The fishing tackle in this picture also serves as an effective frame, and reminds us that there is more to the place than tourism. Although jumbled, the nets make a harmonious shape.

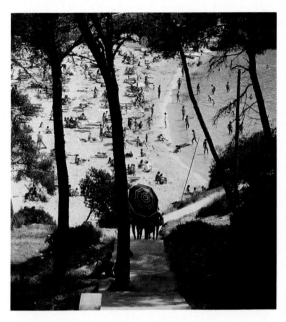

▲ **A crowded beach** can make an interesting pattern if you stand far enough back, so that individuals are transformed into anonymous pictorial elements. Here, I reinforced the pattern by shooting through silhouetted trees, which divide the picture into vertical panels. Another way to strengthen the graphic qualities of beach scenes is to incorporate repeated shapes of towels or parasols.

▼ **A high viewpoint** helps you to make strong shoreline compositions. From sea level, the water will appear as a narrow strip and people on the beach will awkwardly break the line of the horizon. For this picture, I solved these problems by climbing up a sea wall. The main part of the beach was crowded even in the early evening; however, a half-mile walk along the shore revealed this emptier view.

NATURAL WONDERS

Natural wonders such as waterfalls make a deep impression on the imagination – often by virtue of sheer scale. This impact is difficult to put across in a postcard-sized print. Remember, the vantage point that gives the most exciting view may not be best for photography. Use a wide-angle lens with a horizontal picture format to strengthen the sense of breadth, a telephoto with an upright format to convey height. If sheer scale is not the most dramatic feature, evaluate what is – for example, clouds of steam at a hot spring will be most impressive on a cold morning, rather more so in fact than in noon sunshine.

▲ **In caves,** a tripod is virtually essential for photography. When cavers' helmet lamps are the only light source, lock open the shutter of a tripod-mounted camera at its B setting and fire several flashes at different parts of the cave. This will create distinct pools of light in the picture and record trails of your lamp as you move around; however, these particular effects will seldom spoil the image.

▼ **Aerial views** are not as unlikely as they sound: at many natural wonders you can book a trip in a light aircraft or helicopter, without having to pay exorbitant prices. Join the queue early, so that you can sit next to a window. Try to exclude wings or wheels from the field of view. A motordrive will improve camera stability and avoid your having to waste time rewinding when the view beneath is changing so rapidly.

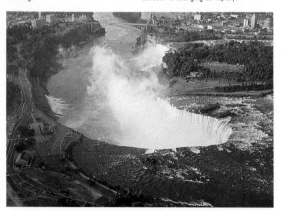

PROJECTS

On vacation, you have virtually unlimited time for photography. Make the most of this luxury by setting yourself a number of specific photo projects. This will give some structure to your picture-taking and ensure that you don't come back with too disjointed a collection of images: at least one subject – whether an obvious one such as family and friends, or a more recherché theme such as rainy-day scenes – will be covered in depth. Some suggestions for thematic photography are offered in the following section. You will probably want to supplement these with your own ideas. Often, a rewarding line of exploration will be suggested by the location. For example, you might choose to make photo-studies of all the castles in the area.

▼ **Vacation themes** need to be chosen with care. Don't cast the net too wide, or people looking at the pictures will fail to see what they have in common. However, if your criteria are too rigid, you'll narrow your opportunities. Here, my theme was local people in Cairo and their reactions to foreign visitors. Handing my spare camera to a friendly bystander produced this graphic shot.

FAMILY AND FRIENDS

Traveling companions, and new friends made on vacation, are among the most popular subjects for amateur photography. Sadly, many such pictures are of interest only to the people who were either side of the camera at the time. But really good photographs of family and friends have an appeal beyond the merely personal. For a picture to work successfully there should be a fusion of face and place. The setting and the human subjects should complement each other, not compete with each other. Above all, avoid just posing someone stiffly in front of a famous landmark: always think carefully about the composition as a whole.

▲ **Monumental architecture** can make an excellent frame for a portrait. In this shot, the casual, relaxed pose effectively contrasts with the symmetry and grandeur of the staircase (in Braga, Portugal). Using a telephoto lens from a distant viewpoint flattened the perspective of the picture, making the walls appear to emerge from my friend's back like a pair of gigantic wings. Note the color match: white and white.

▼ **Moving in close** is often the best strategy for portraiture. When the location is really well known, you need show only a detail of the background: the viewer will quickly identify where the picture was taken. Here, I deliberately threw the surroundings slightly out of focus because the setting — St Mark's Square in Venice — is so familiar through postcards, posters and illustrated travel books.

▲ **Use props** to set the scene. Many pictures of family and friends are dull because the subject is taken out of context, and there is no apparent motive for taking the photograph. Although obviously set up, this picture works successfully because the figures are united by a sense of occasion – a hunting trip. The dogs play an important role too by adding to the sense of movement in the picture.

▼ **The most evocative pictures** – the ones that bring back the best memories of a trip – are often taken in situations that at the time appeared mundane, such as this hotel bedroom. The placid atmosphere of this candid shot comes from the soft light flooding in through the window. I used available light, supporting my elbows on the back of a chair to avoid camera shake during the 1/8 second exposure.

LOCAL PEOPLE

Travel brings us into contact with a whole new spectrum of faces. Instead of restricting yourself to shots of family and friends, why not make a point of photographing local people as well? Provided that you adopt a pleasant, easy-going manner, most people will be flattered by your request that they pose for a portrait. Tradespeople and entertainers will usually be more than willing to show off their wares or skills. But try not to be diffident about asking, or your shyness might communicate itself to your potential subject. As a gesture of goodwill you should take down the subject's address and offer to send on a print.

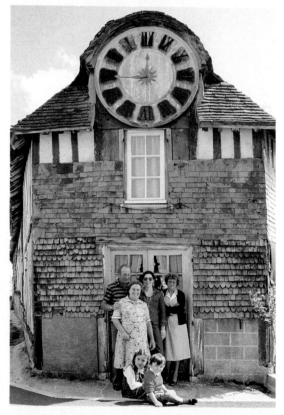

▲ **An appropriate setting** gives extra value to a portrait. It's all too easy to end up with a collection of isolated faces, but shots like this have a special interest thanks to their strong sense of place. This French family were unaware I was using a wide-angle lens to include their picturesque home, so they stood bunched together, thinking that otherwise they would be excluded from the picture!

▶ **Local dress** helps to convey the flavor of the area and you'll often see incongruous mixtures of modern chain-store outfits and traditional clothing. The high sun hid these women's faces in deep shadow, but it would have been a shame to have asked them to take off their decorative hats. So instead I spread a newspaper on the ground to throw light upward and illuminate their smiles.

▲ **Respect** the inhibitions of people from other cultures, and don't attempt to force yourself upon unwilling subjects. Often people are happier to pose in pairs or groups than they are individually, as was the case with these two African sisters. To emphasize their facial similarity I gave the girls identical headbands which they donned eagerly. Closing in with a medium telephoto lens also reinforced the family resemblance.

◀ **Exotic characters** such as this snake charmer may often be persuaded to give you a special performance after the crowds have gone, in return for a modest fee. There will usually be other tourists lingering on the sidelines, but with careful framing and choice of lens you will often be able to exclude them from the picture to obtain an uncluttered view.

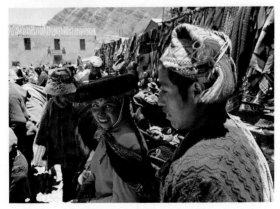

MARKETS AND MEETING-PLACES

Markets and squares provide regular meeting places for locals, with fine potential for candid pictures and views full of bustle and color. Visit markets early in the day, when proud displays of produce are still undisturbed. The light is better in the morning too. Around noon, awnings will tend to hide faces and wares in deep shadow, although you may be able to solve this problem with fill-in flash. Simple cameras are excellent for meeting-places, as they are quiet and inconspicuous. They usually have wide-angle lenses, enabling you to come in close and reduce the risk of anyone stepping between you and the subject.

▲ **Rows of goods** for sale on market stalls can make attractive patterns. Move in until the subject fills the frame: the closer the better. Make sure that no distracting shadows are falling across the picture. Here, to lend movement to a static scene I got a friend to reach across the shot, blurring her hand at a shutter speed of 1/30. Exotic local produce is a good subject for this type of treatment.

▼ **Stall holders** benefit from generous framing, using a wide-angle lens to throw emphasis onto their goods. Here, I chose a 35mm lens – a wider-angle lens would have stretched the fruit near the edges of the picture frame to unnatural-looking oval shapes. Overcast lighting meant that the exposure was not as critical as it would have been in sunlight, so I set the camera in its automatic mode.

▲ **Tradesmen's vehicles** often make a fascinating subject, with lettering as an aid to identification. Frontal sunlight brings out the color of painted carts. To cut down reflections from shiny paintwork, fit a polarizing filter to your lens. Taking this shot with both eyes open enabled me to look out for unwanted figures stepping into the field of view: with a little practice, you can easily do this.

▼ **A position behind market traders** is a good viewpoint from which to point your camera at the customers. From this position, your pictures will also record surrounding streets. Tourists were a novelty in this lively and colorful Indian street market, so to avoid a sea of staring faces in my shots I kept my camera hidden, bringing it out quickly to snatch natural-looking scenes like this before anyone noticed me.

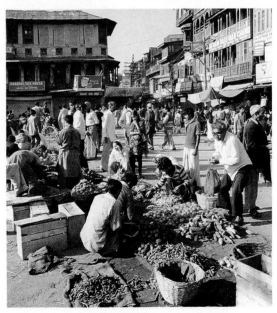

EVERYDAY LIFE

Most travelers enjoy observing people as they go about their
everyday lives. A collection of pictures focusing on local ways of
doing ordinary things makes fascinating viewing, and offers an
insight into places that postcards and guidebooks often lack. Street
life is particularly rich in subject matter: in the space of a modest
photo essay you can build up an informative picture of local dress,
transport, work and recreation. And in the countryside you can
concentrate on the different ways in which the land is farmed. If you
are traveling widely, an interesting project is to photograph one
aspect of daily life in a variety of locations – such as people relaxing
at café tables, or cycling to work, or walking their dogs. Everyday life
is by definition routine, and many people will be more than happy to
break off what they're doing to stare at a photographer. So try to be
inconspicuous, using the techniques described on pages 110-11 to
avoid attracting attention.

▼ **Backstreets** are often full of
documentary interest. To strengthen the
foreground of a view of a Neapolitan
alleyway, taken with a 28mm wide-angle
lens, I chose this plasterer as my main
subject. The lines of festooned washing help
to solve the problem of a dull, featureless
sky, which I wanted to obscure.

▲ **People at work** are excellent subjects, especially when the task performed is a local speciality. To show the nature of the job, avoid framing too closely: above, the white piles and the pools of water help to identify the subject – salt panning in Borneo. A zoom lens set at 200mm compressed the perspective and stacked up the white beds behind the worker to create a bold composition.

▼ **Store windows** offer fascinating glimpses: you can photograph people gossiping, haggling over prices, or just buying the day's provisions. A polarizing filter over the lens will help to reduce reflections in the window, but a mirrored image of the street outside often sets the scene for the interior view. Here, I shaded part of the glass of a Hong Kong barber's to limit the areas of reflection.

CANDID PICTURES

Today's automatic cameras are ideally suited to photographing people unawares – whether friends, fellow vacationers or locals. Such candid shots will add a lively touch of human interest – and often a dash of humor – to your vacation album or slide collection. Prefocus the camera and select a small aperture so that you can point and shoot without having to reset the focus for every fresh shot. Don't hesitate: if your subject sees you peering into the viewfinder, he or she will be distracted and the moment will be lost. With practice, you will develop a relaxed, smooth-flowing style, and take candid shots almost by instinct.

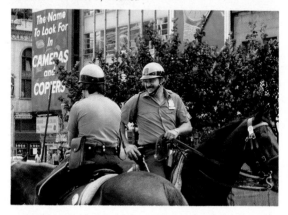

▲ **Quickly snatched images** are best obtained with an autofocus compact camera. The type with a quiet leaf shutter is less likely to be heard than the kind with a motorized wind-on. For this grab shot of two cops sharing a joke, I walked up to within a few feet of them, pulled out my autofocus compact camera from under my coat and rapidly took the picture – without their noticing me at all.

▼ **Wide-angle lenses** are useful for candid shots, because their extensive depth of field makes focusing less critical. At a moderate aperture, the 35mm lens I used for this street scene will render everything in focus between 6 feet and 30 feet from the camera. But it's essential to move in close: many pictures are spoiled because the subject occupies too little space within the picture frame.

◄ **Long-focus lenses** enable you to take candid close-ups without fear of intruding: you can maintain a respectful distance, yet still fill the frame with an expressive or characterful face. For this candid portrait, taken at an African festival, I used a 70-210mm zoom lens, set at around 150mm.

▼ **Prepare yourself** for candid shots by presetting the exposure to suit prevailing conditions. Humorous scenes like this view of a hotel worker laden with cushions may not repeat themselves, so you need to react instantaneously, without having to worry about the camera controls. When using a 50mm lens, stop down the aperture to around f/16 and preset the focus at 7 feet. This will render everything from about 4 feet to 21 feet acceptably sharp.

CHILDREN AT PLAY

Children's games are essentially the same the world over, and it's this very uniformity that makes children at play such a suitable subject for a vacation project. If you have children of your own, encouraging them to play with local youngsters can often yield some lively groupings. Some children thrive on attention, while others become inhibited as soon as they know they are being photographed. If you are in doubt about how your subjects may react, keep your distance and use a telephoto lens. If you're spotted, the best solution is just to wait awhile: the lure of the game will probably overcome shyness in the end. A fruitful approach is to start up an energetic game, then slip away to take pictures when the excitement reaches a high pitch. Viewpoint is especially important when children are the subject. Pointing the camera down from eye-level will make a child's head seem over-large; it is better to crouch down to involve the viewer in the child's world. Never be too stinting with film: children at play dart about quickly, and some wasted frames will be inevitable.

▼ **A child's fascination** with other people's belongings can be the basis of a humorous picture. Bikers outside this French café were perfectly happy to lend their helmets for a game of astronauts. A 28mm lens captured a sense of immediacy.

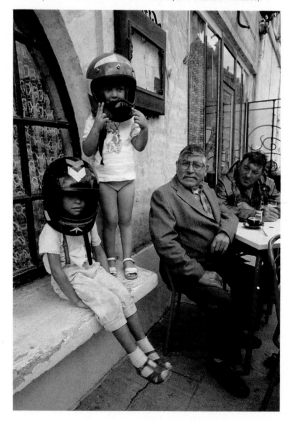

▲ **Posed pictures** of children's games can look as good as spontaneous shots, and give you more control over the setting. To begin with, these children with their white rabbit and toy windmills were lost against a cluttered background of white-painted fences. But with a little help from their mother, I moved them over to a pastel-painted wall which made a better background for the picture.

▼ **Quick reactions** are the essence of successful child photography. This young cyclist was racing along a busy street in a Peruvian town, and for a while I ran level with him, unable to press the shutter until he had broken free of the crowd. The generous depth of field of a wide-angle lens enabled me to set a moderate aperture, which in turn allowed a fast shutter speed to freeze the action.

TAME ANIMALS

Tame animals are more inclined to cooperate with the photographer than wild ones, and are often at least as colorful and exotic. Indeed, certain tame creatures – such as parrots – make especially good subjects because they are specifically bred to be decorative. Take advantage of an animal's fearlessness by moving in close. Try to establish friendly relations before you start to take pictures. The first time you press the shutter, you may get a startled reaction, but in time the subject is likely to get used to the noise. Judicious use of food will help you to maneuver the animal into a convenient position, and may lead to a lively picture. Don't be seduced by an animal's charm into taking pictures that are compositionally weak or that don't capture some particular memory of your vacation. Photographing an animal with its owner is a good way to create a suitable context, as in the picture opposite.

▼ **Animals in motion** always look more natural if they're heading into the picture rather than out of it, so I left plenty of space in front of my subject when I took this shot of a hen in a hurry. What better way to capture the flavor of a vacation spent on a farm than a whole series of animal portraits? However, you should always be sure to ask the owner's permission before wandering around the farmyard.

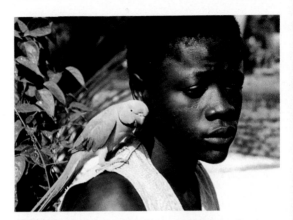

▲ **Colorful plumage** can camouflage birds surprisingly effectively, so choose backgrounds with care. This boy's pet blended in with the bush on the left but against his face the bird's hues stand out brilliantly. Contrast was high, so I used a handheld meter for an incident light reading; unlike a camera's built-in reflected light meter, this is not influenced by subject tones.

▼ **Animals reacting to the camera** – if only by staring – create a relationship with the viewer that prevents a picture from looking too static. Bemused by my activities, one of these magnificent highland cattle turned round to reveal his characteristic pair of horns. The snow on the ground acted as a reflector, throwing light back into the shadows and bringing out the shaggy texture of the coats.

WILDLIFE

On a photo safari, a project on wild animals could last the whole
vacation. However, for most travelers, chances to photograph
wildlife are more restricted. If there is a chance to visit a safari park,
take it: you'll probably come away with a good bag of animal shots,
whereas a day out in the real wilds, even with a guide, will often yield
only a few momentary glimpses of local fauna. Take the longest lens
you have, to close in on timid animals from a distance, but don't
leave behind your shorter focal lengths. Some animals get used to
humans, especially in parks, and it's a shame to find that you can't
focus your 400mm lens close enough to take in the chimp on your
auto's hood. Take fast film: long lenses need to be stopped well
down for adequate depth of field, and can only be handheld at fast
shutter speeds. With slow film, even in bright sunlight, you'll end up
with either shallow depth of field or camera shake.

▼ **An extra camera body** can be useful
when stalking shy animals like this deer.
Keep a long lens on one body and a standard
lens on the other. If you catch up with an
animal, you may have only seconds to take
the picture, and you certainly cannot afford
to spend time changing lenses. Even focusing
has to be quick, so keep lenses focused on
the middle distance: adjustments will then
be minor.

▲ **At the zoo,** finding the animals is, of course, no problem; but taking natural-looking pictures may be. Frame the animal tightly against foliage or the sky. Blur the netting or bars by setting a wide aperture, and pressing the lens as close to the barrier as possible. Here, I used a telephoto to reduce depth of field still further, so that the net between me and this owl is totally invisible.

▼ **On safari** your timetable will be dictated by the habits of the creature you plan to photograph. In hot climates, animals are most active around dawn, so arrange to leave several hours before sunrise if possible. At this time, the best spots to watch are water-holes: you may see several species drinking together. Later in the day, look in the shady places where the creatures snooze.

SHOWS AND PERFORMANCES

Whether held on an indoor stage or in some kind of open-air arena, performances make lively, colorful subjects for the camera. Forward planning is always advisable. First, find out whether there are any rehearsals you can attend. These are more relaxed than public shows, so you'll find it easier to get close to the performers. Moreover, lighting at rehearsals tends to be less harsh than the stage lighting used for the real event, so picture-taking is easier. Before photographing a performance, check that you are allowed to do so. If you are, try to get a seat that provides a clear view of the stage – ask if you may see the auditorium before choosing. Take along a selection of lenses or a zoom, to multiply your picture opportunities without having to move from your seat. Although tripods are seldom allowed, it's worth asking if you may use a monopod. To cope with dim stage lighting, either use ISO 1000 print film, or load fast slide film and rate it at one or two stops above its nominal speed (remember to ask the lab to adjust development accordingly).

▼ **A diffraction filter,** which spreads spokes of color across a picture, is especially appropriate for heightening the atmosphere of glittery stage shows. These filters work by breaking up bright highlights into the colors of the spectrum.

▲ **Stage lighting** often misleads exposure meters, especially when spotlighting is used. If you have a zoom lens, try this solution: zoom in to fill the frame with the brightly lit area; take a meter reading and set this on the camera's controls; then change back to the shorter focal length to take the picture. It is always advisable to bracket.

◄ **Folk dancers** tend to make the same movements repeatedly. Observe the patterns, so that you can anticipate images like this before they arise.

▼ **If you fail to get in,** don't give up hope of coming away with some good photos. You may catch the performers arriving, or obtain effective candid views of other unlucky spectators. I took this shot outside a stadium where a rock concert was held.

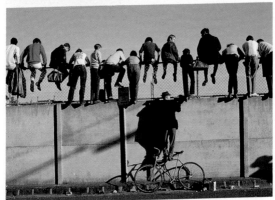

119

CARNIVALS AND FESTIVALS

If there's any kind of open-air festival planned in your vicinity, be sure to take along your camera. Even quite unpromising events often have spectacular surprises. You may wish to spend most of your time joining in the fun, but it's always worth devoting half an hour or so to serious picture-taking. Survey the site beforehand to find suitable viewpoints. Arrive early if you think there might be competition for the best positions. To capture the flavor of the event, combine close-ups of characters and costumes with wide-angle views. Experiment with slow shutter speeds or moving the camera for impressionistic shots that capture the action.

▲ **Spectators** can be just as photogenic as the participants. This scene at the annual Henley Regatta on the River Thames, seemed to epitomize a uniquely English kind of entertainment — waiting in the drizzle, sitting on a copy of *The Times*. A 28mm lens gave the image great depth, which is emphasized by the distinct horizontal bands formed by the platform, the grass, the river, the trees and the sky.

▶ **Carnival masks** like this one look especially good when they are made to fill the picture frame: often, more workmanship goes into the mask than into the rest of the costume. In this medium telephoto shot, a wide aperture reduced depth of field to concentrate attention on the bizarre beast's head by blurring the background. Loading with ISO 400 print film allowed a fast shutter speed to freeze movement.

◀ **Fireworks** make an exhilarating conclusion to festivities. To recreate the excitement, set up the camera in a firm position – on a wall or better still a tripod – and frame the picture in advance. Set f/8 for ISO 64 or 100 film, f/16 for ISO 200 or 400, f/22 for faster films. Keep the shutter locked open for several minutes with a cable release, covering the lens with the lens cap between the most dramatic bursts.

▶ **Learn to shoot on the move** if you want to capture the action. Parades are constantly in motion, and though bridges or buildings overlooking the route provide excellent viewpoints, you may prefer instead to mingle with the crowd to increase your photographic chances. When you are caught up in the crush, a wide-angle lens will simplify focusing. Set a fast shutter speed to avoid blur.

RAINY-DAY THEMES

Rain needn't signal a rush for cover. A shower provides the chance to compose pictures with a new palette of colors: instead of the brilliant hues revealed by sunlight you will find muted tints with a subtle beauty of their own. Most cameras are well sealed against moisture, and resist a fine misting of drizzle; but in heavier rain protect your camera with a plastic bag. Cut a hole in the bag for the lens, and use a rubber band to seal the edge of the hole (you'll find this easier if you use a metal lens hood). Cover the lens with a filter. If raindrops do splash on the glass surfaces, wipe them off before they dry, or indelible marks may form.

▲ **Rainbows** appear and disappear rapidly, so act immediately when you see one. After rain, they occur in the area of the sky opposite the sun. (You may also find them around waterfalls and fountains). To intensify the colors, take a meter reading from the sky behind the rainbow, then give one stop less exposure than indicated. If you can, balance the rainbow with a landscape feature to strengthen the picture.

▼ **Look for reflections** in wet streets. You'll see a really brilliant mirror effect when the reflecting area is in shadow and the object reflected is in sunlight. But as this New York scene shows, you can make effective pictures even in the dull light from an overcast sky. In this type of shot, the brightest reflections are formed by pale colors and by light sources such as car tail lights and neon signs.

▲ **A slate-colored, rain-laden sky** pierced by sunlight is a recipe for marvelously atmospheric pictures. Here, I deliberately restricted the range of colors to evoke the empty, melancholic feeling of an off-season vacation resort. Light from an overcast sky tends to be overly blue, so to redress the balance in this picture I fitted a pale-straw colored 81B filter over my 28mm wide-angle lens.

▼ **Heavy rain** shows up in photographs, but drizzle and showers don't. So to make it clear that rain is falling, show the effect of the weather: figures scuttling past under umbrellas; splashes of water on puddles; or, as in this close-up picture, dripping railings and foliage. Frame the raindrops against a dark background, and move around the subject until the water catches the light with an attractive sparkle.

LOOKING FOR PATTERNS

A camera compresses three dimensions into two – a process that often reveals graphic patterns of color or tone, which we tend not to notice until a scene is translated onto film. Any environment has a potential for yielding patterns, but the sheer familiarity of places near home often makes us blind to their visual possibilities. On vacation, everything seems fresher, and it is suddenly easier to create exciting graphic images. So spend a couple of hours looking around for suitable subjects, like the ones illustrated on these pages. Try looking with one eye – it will flatten the scene and help you see the world more as a camera does.

▼ **Sunlight and shadow** can add magic to the most ordinary places. This corner of a modern building looked drab and ordinary on a dull, rainy day; but when the sun broke through the clouds, extremes of light and dark made an eyecatching pattern, with dancing highlights reflected off a wind-blown puddle. My eye was caught by the hexagon formed by the staircase, roof and wall, and I decided to make this the focal point of the picture. With my SLR camera set to the manual mode I moved in to take a meter reading from the sunlit wall: exposing for this bright area ensured that other parts of the picture would appear as a dark frame of shadows. Images like this rely on clarity and detail throughout, so I set a small aperture – f/11 – to keep everything crisply in focus.

◀ **The natural world** is full of patterns, many of them very regular. Although some natural forms make patterns of generous proportions, repeated or geometric shapes are more likely to be found in miniature. You will therefore tend to have greater success if you move in close to the subject, using one of the lenses or camera accessories illustrated on pages 11 and 13. I was fascinated by the lines running along the edges of these leaves, but the surroundings and the other parts of the plant were merely distracting. I therefore used a 50mm macro lens, framing the picture from a distance of about nine inches (25cm). To emphasize the formal regularity of the structure, I took care to place the chevron shapes in the exact center of the picture frame. The leaves were spread out in a flat plane, so depth of field was for once not a problem. The image was one of a series of Mexican plant patterns.

▶ **Upward views** sometimes produce novel images. In a woodland, a vertically upward view will show converging tree trunks with a pattern of branches or leaves overhead. Indoors, the view may be equally photogenic. Despite appearances, this photograph shows not a stairwell but the interior of a museum — the Guggenheim, New York. A 20mm lens made it possible to include all levels of the gently spiraling passageway.

▼ **The flattened perspective** effect of a long telephoto lens tends to emphasize pattern at the expense of form, as in this landscape made up of interlocking triangles. Look for repeated elements like these bushes that form a pattern within a pattern. Often, a high viewpoint will unfold patterns that are invisible from ground level.

125

DETAILS

As we travel around, it is often the minor differences between places that make the most immediate impact. One village has houses roofed with slate; yet 25 miles away the roofs are pantiles. Make a point of looking for such details: they can say as much about a place as a sweeping vista of a main street or a proudly tended local landmark. Even details that offer only the flimsiest clues to location can be used as a basis for effective semi-abstract compositions, like the one at the bottom of this page, and if you wish you can use these shots to change the pace of a slide show or album display. Remember to look up, for details above head height.

▲ **A bygone era** of packaging is recreated in this shelf display in a restored grocery store. A broad view of the store would have given a better impression of the architecture of the period. But instead, I chose to close in, so that the lettering would be legible in the photograph. A 28mm lens ensured that the scene would have some depth to it: from farther away with a longer lens, the image would have seemed too flat, like a painted mural. The late-afternoon sunlight gives a golden glow to the scene, which heightens the atmosphere of nostalgia.

▶ **Slow color slide film** ensures that your details will be as crisp as possible, with maximum texture. For this semi-abstract shot of rust stains caused by nails in sun-bleached timbers, I used Kodachrome 25.

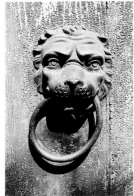

◀ **Door knockers** could make a theme in themselves, since there is an apparently endless variety. This benevolent-looking lion guarded the door of a house in Italy. The 50mm macro lens which I used for the picture is ideal for shooting details. Without accessories, the lens will almost fill the frame with an object just three inches across — yet with a turn of the focusing ring you can also use it for distant views. Here, I stopped down to f/11 to increase the depth of field and thus keep the knocker in focus from front to back.

▼ **Time of day** and the weather have just as much effect on details as on broader views. Bright sunlight cast shadows across this wall, partly obscuring the painted lettering, so to take this picture I returned on a dull day when the light was more diffuse.

REFLECTIONS

Reflections are so much part of life that they usually pass unnoticed. Only when you start looking for them as photo subjects do you realize how many there are, and in what a wide variety of surfaces. This abundance is precisely what makes reflections such an ideal vacation project. When you've taken a photograph in the conventional way, look around and you'll probably see the same subject reflected somewhere. You can always cheat and manufacture a reflection – for example, in the shiny bumper of your car. Reflections are most clearly visible when the shiny surface is in shadow and the subject itself brightly lit. If you have an autofocus camera, it will focus on the reflector, not on the image. To solve this problem, estimate the distance from camera to reflector and from reflector to subject, and add these two figures together; now find some other subject this distance away; operate the focusing mechanism (usually by half-depressing the shutter release); then recompose the picture and press the shutter release fully home.

▼ **The sun's reflection** always creates exposure problems. Usually, the best approach is to take a substitute meter reading from a non-reflective surface nearby – such as the rocks in the foreground of this view across a mountain lake.

▲ **Modern architecture** is a rich source of reflections. Look particularly for mirror-surfaced office blocks: tightly cropped images of these can form semi-abstract patterns, as each individual sheet of glass forms its own reflection of the scene opposite. However, for this shot I took a broader view to show both the reflection and the building in which it occurs.

◄ **Reflections on water** tend to shimmer constantly as wind or vibrations distort the surface. Even gentle ripples can create highly complex reflections, which you can use for creative effect. To avoid too chaotic a composition, look for subjects that have bold patterns, shapes or colors. To distort the straight reflections of these reeds at the edge of a pond on a windless day, I lobbed a small stone into the water.

NATURE IN CLOSE-UP

Even in the course of quite a short journey away from home, you may pass through a range of habitats, where unfamiliar flowers, insects, seashore creatures and other small-scale wonders will captivate your eye. To photograph such phenomena, it helps to have some close-up equipment. This, however, needn't be prohibitively expensive. Many zooms have a handy macro setting (see page 8). Other possible choices of equipment include a close-up lens (which screws into your main lens, like a filter) or a set of extension tubes (to increase the distance between your standard lens and the film and thus allow closer focusing). At close subject distances, depth of field is greatly reduced, so stop down and focus meticulously.

▲ **Snails and slugs** seem to move surprisingly quickly when seen in close-up: this little snail crossed the frame in just a few seconds. To cope with nature's tiny sprinters, don't use a tripod – it will slow you down. Instead, it is preferable to handhold the camera and focus by rocking back and forth: this is much quicker than turning the focusing ring.

▼ **A teleconverter** will magnify the image without changing the closest focusing distance of the lens to which it is attached. At the 14-inch (36cm) minimum focusing distance of a standard lens, this moth hardly made a worthwhile subject. However, with the aid of a 2 × converter it nearly filled the picture frame, creating an attractive image of miniature beauty.

◀ **Use flash** to provide supplementary lighting, as I did for this picture of the uninvited guest that shared my hotel room. Flash freezes the most rapid movement and at close range allows you to use small apertures, thus helping to solve depth of field problems. For best results you should hold the flash at one side of the subject. Use the flash in the manual mode. Before setting off on your trip, run a series of exposure tests to determine the correct aperture for various subject distances.

▼ **Flower pictures** tend to disappoint unless you either come in close or show the flowers in the context of their habitat, as I did for the Australian view below, taken with a 24mm wide-angle lens. An excellent time for close-ups is early morning when the plants are still fresh with dew.

MAKING A PICTURE ESSAY

A remarkable number of travelers take just one photograph of each subject, and regard extra exposures as an extravagance. Yet compared with the cost of a vacation, the price of extra film and processing is insignificant. If a place particularly impresses you, use it as the basis of a picture essay, like the one here showing different aspects of the Palace Pier, Brighton, England. To work successfully, such essays need to be planned thoroughly at the picture-taking stage rather than assembled as an afterthought when your film is returned from processing. Remember, your aim is not to take one picture that says it all: instead, the intention is to use a half-dozen or more shots to build up a multiple impression. Cover the subject from all angles and vary the scale from close-up to long shot. Shoot both horizontal and vertical views, and experiment with various exposure settings and perhaps with filters. Return at various times of day and in different weather conditions to catch the subject in all its moods. SLR-owners should plan at least two views with each lens.

▼ **Set the scene** with a middle-distance shot, designed to put all the other images in context. Avoid using special effects or odd angles that might make the subject hard to identify. Keep the composition simple and the background uncluttered.

▲ **Walk around** your selected site and capture the succession of views that any visitor would experience while exploring. This symmetrical view presents itself as you climb the staircase to the end of the pier. Notice how the filigree ironwork preserves thematic continuity with the previous image in the essay.

◄ **People** add an impression of life but may be distracting if the main point is the architecture. Here, to capture the magic light of early evening, I chose to wait patiently for a break in the flow of strollers.

▼ **You can be more adventurous** in your compositions once you have set the scene. For example, your audience will pick out the subject even when you choose to keep it small within the frame or obscured by dim light.

133

TELLING A STORY

Looking back on a vacation, we often recall isolated moments, such as a beautiful sunset or the view from the top of a bell-tower. But often some of the most cherished memories are brief narratives, like scenes from a play. With a camera you can suggest such a narrative more easily in a whole series of pictures than in a single frame. Be sure that each picture says something different, but for continuity's sake try to maintain some link – such as keeping the background the same – from one picture to the next. Shoot lots of film, so that you end up with a choice of images from which you can pick the best to sum up the narrative.

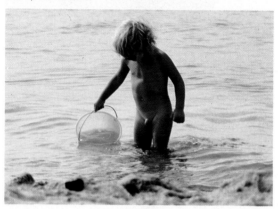

Children's games make excellent subjects for picture stories, because they are so often repetitive, enabling you to have several attempts at shooting each stage. These four pictures were culled from not one but several trips to the sea to fill the bucket. Notice how each image makes a different point: filling the pail; carrying it out of the water; striding up the beach; filling the dinghy with water after transfering it to a plastic watering can. Like a joke, the story has a punchline too, because the boat performs exactly the opposite of its normal function: it holds the water in, not keeps it out. I used several lenses to take these pictures, but found the 200mm telephoto most useful as it enabled me to keep a discreet distance, so that the little boy paid me little attention and became thoroughly absorbed in his rather pointless but enjoyable game.

SEASCAPES

In most seaside vacation photographs, sea and shoreline form merely a backdrop to portraits and action shots. However, seascapes make fascinating subjects in their own right. Where land, sky, sea meet, the scene is subject to dramatic changes over short periods. This protean character makes the coastline an excellent theme for a photo essay – especially if you have a room overlooking the sea. Photograph the same view at different times of day and in different weather. Color is a major element in seascapes, so use slide film to record the subtle tints. Some pictures benefit from slight overexposure, to bring out the pastel shades.

▲ **The graphic potential** of sky and sea is unlimited: they form bold areas of color separated by the straight lines of horizon and surf. Try variations on this simple idea by altering shutter speed and focal length. For this picture I used a 28mm wide-angle lens to include the waves lapping at my feet and a fast shutter to freeze the white-capped waves. I cropped the resulting upright print to a square to lower the position of the horizon.

◄ **Brilliant white breakers** can sometimes mislead the camera's meter, with the result that the waves come out gray. If you take a reading from the waves themselves, give at least 1½ stops more than the meter indicates, or else take a reading from an area that is closer to a gray tone – like the patch of sea at the bottom right of this picture.

ACTIVITIES

Vacation photography usually often has to be squeezed into a busy schedule of pleasurable pursuits. Some of these will be relatively relaxed – such as visiting a nightclub or restaurant – while others will be athletic, especially on a sporting vacation. At intervals it is well worth detaching yourself from the activity to explore its photographic opportunities. The snapshot approach is perfectly valid, particularly if you have an autofocus camera; but you are likely to obtain more satisfying compositions if you take the time to consider factors such as viewpoint, background, depth of field and (with SLRs) lens choice – just as you would when photographing a static subject such as a monument. Try to shut off your ears to the sounds and look at the scene in purely visual terms. The best pictures will usually result from a reasoned assessment.

▼ **To exploit the full potential** of an event, you may need to move some distance from the crowd. At this balloon race, most spectators stood with the sun behind them. By hiving off from the throng and crossing the field, I obtained this effective backlit shot.

EATING

Meal times assume a special significance on vacation, offering the chance to taste exotic cuisine or unwind after a tiring stint of sightseeing – as well as an opportunity to photograph children and adults together in relaxed groupings. At all but the most stuffy restaurants, cameras are accepted as a matter of course, so you need have no qualms about taking pictures. To include the staff in the frame, as in the picture below, a little flattery often works wonders. Don't wait until the end of the meal before capturing the scene – leftovers and dirty plates are not usually photogenic. If you're catering for yourself, you will have time and space to set up your shots more carefully, and perhaps compose some evocative tabletop still lifes.

▼ **Window light** is well suited to photographing in restaurants: the tablecloths acts as a reflector, throwing light back into the shadows. However, in a room decorated in dark colors, it may be advisable to use fill-in flash. Avoiding overlighting, or you will ruin the atmosphere. The picture below presented special problems because of the mirrors. The standard way to avoid a reflected self-portrait is to shoot with a long lens from shadows on the far side of the room. But to show the food to best advantage I had to use a wide-angle lens. I therefore lined up the camera with the mirror's wooden center and crouched on the floor to release the shutter.

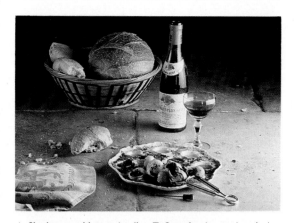

▲ **Simple compositions** are best if you want to create a successful food still life: too many dishes will produce an effect that is merely cluttered and confusing. For this image I moved everything onto the flagstoned floor, which was much more appealing than the garishly patterned tablecloth. I lit the scene by flash bounced off a white dishcloth held at one side of the camera.

▼ **Capturing** the atmosphere of a busy restaurant isn't always easy. Three techniques helped here: first, daylight film used in the tungsten light of the room created a warm, welcoming color effect; next, a slow shutter speed conveyed the tireless efficiency of the staff; and finally a second exposure on the same frame from a slightly different viewpoint doubled the impression of bustle.

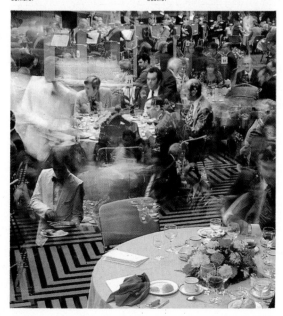

BEACH GAMES

A beach is the perfect location for pictures of exuberant athletics. Sand and sea provide plain, uncluttered backgrounds, and even on dull days the sand reflects plenty of light so that you can set shutter speeds fast enough to capture on film the most active of games. The secret with such shots is to sum up the whole point of the game or activity in a single image. Be on the alert for the best moments, and don't hesitate to ask your subjects to repeat a particularly telling episode if you miss it the first time around. Take special care with exposure, as bright sea and light sand can easily mislead your camera's meter and result in underexposed images. (You will find advice about how to avoid this problem on pages 30-31.) Remember that sand, like sea water, is the camera's enemy. Towels and beach mats pick up tiny grains that will soon grind their way into lenses and interior mechanisms; so always keep your camera well shielded when it is not actually around your neck.

▼ **Sand cushions a fall**, so you can encourage youngsters to perform acrobatic feats that might be dangerous on a harder surface. In this picture, the graphic triangular arrangement of the figures is strong enough to overcome the rather confusing background of shacks and chairs. I took the shot with a 35mm compact.

▲ **Splashing water** always conveys the sense of joyful abandon — indeed, the sea can look dull without it. Normally, it is wise to keep the horizon straight in a composition. But for this picture, taken with a 200mm lens, I felt that a tilted horizon would be appropriate to the theme of man overboard.

◄ **A well-trodden beach** has an interesting dimpled texture, which I used here as the background to an amusing wide-angle portrait. Notice how the line of stones and the colorful towel help to draw our attention to the captive's unconcerned face.

▼ **Sea-washed sand** makes a neat, plain background, free of litter and footprints. It was the ideal setting for a portrait of these toddlers playing absorbedly with their toys.

NIGHTLIFE

To capture the fun at nightclubs, dance halls and discos is a challenging photographic project. To cope with the dim lighting, flash is a tempting option; but as the pictures opposite illustrate, you'll almost always obtain more atmospheric pictures if you rely instead on available light. You'll have to set slow shutter speeds and wide apertures, so load the fastest film you can and brace the camera against a chair, table or wall to minimize camera shake. With slide film, you can make better use of what little light there is by setting the camera's ISO dial to double the film speed; then ask the processing lab to adjust development to compensate. Remember, though, you must expose the entire film at the higher rating.

▲ **Blurred areas** in an image can help to convey the rhythms of dance. Despite the ultrafast film I was using for this shot of a traditional dance (ISO 1600), the camera's meter indicated a shutter speed of 1/4. I decided to turn the inevitable blur to advantage, and pressed the shutter release just as a quick turn made the woman's dress billow out at the right of the picture.

▶ **Discotheque lighting** changes constantly, so it is best to use your camera in its automatic mode. For this expressive wide-angle view I rested the camera on the rail of a balcony overlooking the dance floor — well away from the vibrations of the loudspeakers. As a further safeguard against camera shake, I released the shutter using the camera's self-timer.

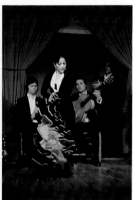

▲ **Electronic flash** arrests movement but drains atmosphere. If you have to use flash, try to ensure that most subjects are at roughly equal distances from the camera: that way, they will all be lit equally brightly. Bouncing flash off a white ceiling or white walls also helps to even out the lighting. To keep subjects sharp but with a blurred trail of movement captured in available light, try using flash at slow shutter speeds.

▲ **Inaccurate colors** can sometimes add to the atmosphere of a picture, as in this flamenco scene where the tungsten room lights captured on daylight film, created an attractive warm cast. However, if you do want color fidelity, choose color negative film, which performs well with a wide variety of light sources: usually you'll obtain perfectly natural-looking results without having to resort to a corrective filter

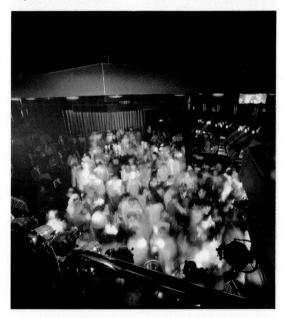

SWIMMING

For many people, the greatest of all vacation pleasures is to lie on a sun-drenched beach or by a pool, cooling off periodically in the water. For photographers, these plunges are truly lucky dips, because swimmers make natural photo subjects. If your companions are swimming or diving, their attention is fully absorbed and you can therefore take pictures of them behaving without self-consciousness. People splashing around vigorously make lively action shots, although you need to select the shutter speed with care. In shots of underwater swimmers, body shapes will be distorted in graceful shapes: the more turbulent the water, the more fragmented the effect. Don't neglect the opportunity for glamorous swimsuit shots like the one below. Try using the vivid colors available on the beach and by the poolside as effective elements of your compositions: in a predominantly blue setting, bright splashes of red always look particularly effective.

▼ **Rippling water** often creates intriguing reflections, which can be used to strengthen a composition. In this sunny portrait, taken in an indoor pool, they add useful foreground interest. To capture the full effect of these ripples, I used a wide-angle lens. The bright red swimsuit and the blue tiles of the pool edge enliven the picture.

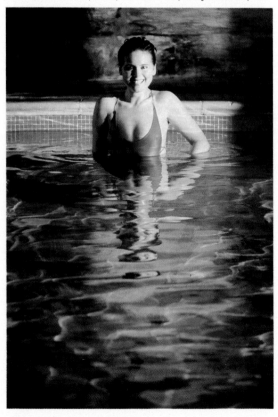

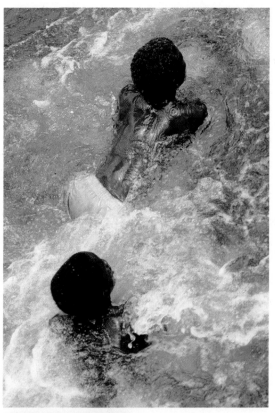

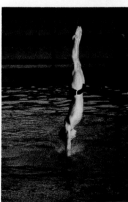

▲ **A high viewpoint** enables you to exclude distracting details, such as regiments of deckchairs around the pool. A diving board offers a good vantage point, while for seaside pictures you can use piers, jetties and breakwaters. To make water look really wet, as here, set a moderate shutter speed such as 1/125: faster speeds make splashes look icy or glass-like.

◄ **Use flash to freeze a dive,** as I did for this spectacular shot. When daylight is fading you can catch pictures like this one even with a simple camera that lacks fast shutter speeds. You'll obtain the briefest flash (and therefore stop action most effectively) when the flashgun and the subject are fairly close together. For the most successful lighting effects, position the flash at one side of the camera.

WATER SPORTS

Sailing, surfing, windsurfing and waterskiing can all look spectacular on film. If you're taking pictures from a boat, put safety before photography. Never get so absorbed in picture-taking that your craft poses a danger to other vessels or interferes in a race. If using a motorboat for maximum freedom of movement, ask your subjects for their cooperation beforehand. Handling a telephoto lens at sea is tricky, but with practice you should be able to avoid the most common problems encountered by beginners – camera shake and slanting horizons. Always keep your equipment well-protected from corrosive salt spray.

▼ **A waterskier** can be photographed successfully from the deck of the power boat that tows him, although this calls for special camera techniques. The vibration from the engine makes a fast shutter speed essential to prevent camera shake. Additionally, it is wise to isolate the camera against vibration by kneeling on a cushion on the seat at the stern of a boat. Fortunately, focusing and adjustments to depth of field are simplified by the fixed length of the tow rope. Try to eliminate shoreline clutter that might mar the background of your shots. For the picture below, I arranged with the driver and skier a series of sharp turns, to enable me to capture the veiling sheet of spray that makes this such a photogenic sport. The spray obscured cars and spectators.

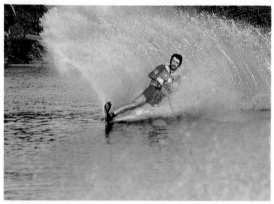

▲ **A viewpoint on dry land** means that you need not worry about getting your camera wet. But for really good photos from the shore, it is advisable to take at least one telephoto lens, preferably with a 2 × converter. For the picture above I used a 300mm lens. Noticing how the late afternoon sun streamed attractively through the sail, I waited until the craft came close enough to dominate the frame. For this kind of shot, a breakwater is handy to bring you close to the action.

◀ **From a boat** there is a wider choice of viewpoints, and you can also come closer to the subject – provided that you do not make a nuisance of yourself by churning up the water. For this simple but effective profile shot I was near enough to be able to use a 50mm lens.

▼ **Splash-proof cameras** offer protection against salt spray. Some, like the Hanimex 110 shown here, are even usable beneath the surface. A cheaper alternative is to buy a waterproof housing for your existing camera. The simplest type consists of little more than a heavy-duty plastic bag, which will keep out spray efficiently, but may not work if you take a tumble over the side of a boat. When using an ordinary camera without a housing, keep your back to the spray except when taking pictures.

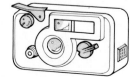

UNDERWATER PHOTOGRAPHY

Although many of the sea's natural wonders are at scuba-diving depths, there are also many fascinating subjects closer to the surface – particularly where there are offshore coral reefs. All you need to photograph this teeming world is a snorkel tube, face mask and an inexpensive waterproof camera, such as the Hanimex illustrated on page 147. If you haven't dived before, it's worth taking a sub-aqua course before your vacation. The most successful underwater pictures are usually close-ups, because suspended sediment in the water makes distant subjects appear flat and indistinct. Load fast film (such as ISO 1000 print film) and shoot when the sun is at its height and the sea is calm. At depths of 12 feet or more, flash is necessary to capture the full spectrum of colors: as you dive deeper, the sea water filters out all colors of light except blue, until at 40 feet pictures taken in natural light appear monochromatic. The flash unit should be as far from the camera lens as possible, or particles in the water will reflect light straight back to the camera – a phenomenon known as "backscatter". If the thought of diving seems rather terrifying, you may still be able to take underwater pictures from a clear-bottomed boat; if so, use a polarizing filter to cut down the reflections.

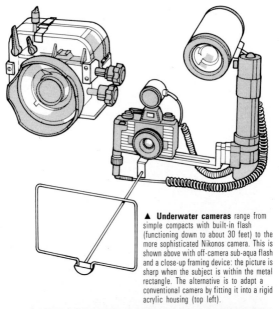

▲ **Underwater cameras** range from simple compacts with built-in flash (functioning down to about 30 feet) to the more sophisticated Nikonos camera. This is shown above with off-camera sub-aqua flash and a close-up framing device: the picture is sharp when the subject is within the metal rectangle. The alternative is to adapt a conventional camera by fitting it into a rigid acrylic housing (top left).

◀ **Tilt your camera** upward for best results. The sea's surface will make a colorful backdrop against which you can silhouette other divers or the hulls of boats. A downward-angled camera, on the other hand, will yield a black background if the water is deep. It is effective to contrast a distant silhouette with a foreground feature brightly lit by an underwater flash unit, as in the picture opposite.

▲ **Sea creatures** abound in the shallows. I photographed this jellyfish in natural light just 10 feet down, diving with a snorkel and face mask. I made two dives: first to locate the subject, then a second dive to take the picture. Because the human body is buoyant, a useful trick is to dive deeper than your subject — you'll begin to float upward as soon as you put both hands on the camera.

WINTER SPORTS/1

Winter sports enthusiasts enjoy the double appeal of snow-mantled mountains and exhilarating activity. For best photographic results, decide which aspect to emphasize: don't try to give them both equal weight. Protect your equipment against the cold (see page 17) and remember to give extra exposure to compensate for reflective backgrounds. Dress on the layer principle: most winter sports photography involves walking some distance to find the best viewpoint, and this will make you hot; but once you take up your vantage point you may have to stand around waiting for the action, and will then need more insulation.

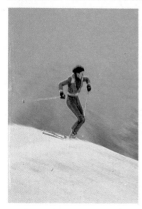

◀ **A skier's movement** can generally be frozen at a shutter speed of 1/500 if he or she is traveling across the frame. However, 1/250 will suffice if the figure is coming toward you or is relatively small within the picture. To photograph racing events successfully, you'll often need faster speeds.

▼ **The distinctive postures** and clothing of skiers make them excellent subjects for experimenting with camera movement. Their outlines will survive a considerable degree of blur and their colorful garments look spectacular against a white background. To take this picture I panned with a handheld camera at 1/15. For more conventional panning (keeping the subject sharp against a blurred background), use a monopod: a tripod is useless on steep, slippery slopes.

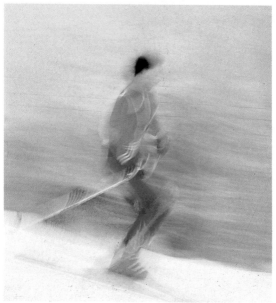

▲ **Graphic postures** can suggest movement even when the subject is fairly static. Curling, for example, is a form of bowls on ice, and involves only limited activity. To make this shot taken at a curling match more dynamic, I stood behind one of the competitors and pressed the shutter release just as he swung his arm back prior to sliding the heavy stone.

◀ **Generous framing** will help to ensure that you don't lop off the arms or legs of sportsmen. The best viewpoint depends on the sport. For this picture, I stood near the bottom of the hill, looking upward to catch the tobogganist's face and create a strong diagonal using the edge of the track where snow contrasts with dark trees. For skating pictures, try to capture the participants as they turn at the edge of the lake or rink.

151

WINTER SPORTS/2

When the temperature drops, you may have to change your technique a little. In strong winds, beware of wind-blown snow, which you should quickly flick off your camera with a soft brush: don't blow the snow off or your breath will condense and freeze on your equipment. It is sensible to use a zoom lens, to avoid lens changing and thus reduce the risk of your breathing on sensitive interior lens mechanisms, or of snow entering the camera. A common error, not always visible through the viewfinder, is to allow condensed breath to drift into the field of view. This will appear on the image.

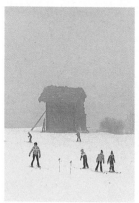

◄ **Long shots** of ski action may not be as dramatic as frame-filling slalom racers, but they probably represent more accurately the way that most holiday skiers spend their days on the snow. I returned repeatedly to this nursery slope, attracted by the ''stick-person'' qualities of the first-time skiers. As the weather changed, so did the scene. Mist totally concealed the other side of the valley, but when the sun eventually broke through, houses, walls, tracks and trees formed a richly textured backdrop, providing me with dramatically different picture opportunities. It was bitterly cold, so I wore a front-opening parka, keeping equipment and rolls of film inside so that they would benefit from body heat. I took care to include one unchanging feature — the ramshackle hut — in every frame: this added an immediately recognizable continuity to the picture series.

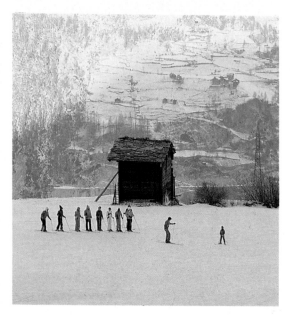

HOME AGAIN

The end of a trip is not a conclusion, merely a pause, in the vacation story. Still to come is the pleasant task of sorting through your pictures and selecting the best images to display. Instead of adding your prints haphazardly to your all-purpose family album, it is well worth making a special vacation album, lavishing plenty of care on presentation. For captions, use transfer lettering if you feel that your handwriting is too untidy. Slide shows deserve an equally considered approach. To augment the images, try using suitable music or a well-scripted commentary. Some variations on these ideas, together with hints on processing and storage, are given in the following section.

▼ **Presentation** is as much a part of the creative process as picture-taking itself. Treat your vacation album as a well-planned showcase. As a frontispiece or cover picture, choose an image that sums up the whole vacation experience. For example, this view of Salisbury Cathedral, framed by a misted window, was used on a photo album cover to sum up a week of visiting historic buildings in Wiltshire, England.

PROCESSING AND PRINTING

Processing and printing costs may come as an unpleasant surprise to many people – especially if they have overspent on vacation. However, there are ways to economize. With slide film, you can save on costs by asking for processing without mounting: you can then mount just the pictures that you intend to project. You may in any case prefer your own card mounts, as photo labs use plastic mounts which are hard to write on. If you used negative film and want extra sets of prints made for traveling companions, order them at the time of processing: this is less expensive than reprinting selected negatives later. When you wish to enlarge just a small area of a particular negative, you can save by ordering a giant print, and then cropping off the unwanted borders. Don't be afraid to ask the lab to reprint your pictures if you're dissatisfied with them – at peak times, processing labs handle tens of thousands of films per day, and inevitably a small fraction falls below standard. Label each roll with your name and address in case the lab's records get mixed up. With slide film, it is sensible to have just one roll processed in advance. These test pictures will show whether your camera was exposing the film consistently correctly, and if not you can request the lab to compensate on subsequent rolls.

▶ **Exposure errors** on slide film can be corrected at the processing stage, provided they are not too radical. A common mistake made by photographers is to change from a fast film to a slow one, or vice versa, without altering the ISO dial on the camera. If you discover half-way through the film that you have done this, don't alter the dial – instead, expose the whole film at the same (incorrect) film speed, and mark the film to indicate the development adjustment needed, in stops: for example, an ISO 64 film exposed at ISO 200 would need 1½ stops extra. Explain what you have done when you take the film to the lab. You can also use this method to boost the speed of film exposed in low light. ISO 400 film, for example, could be pushed two stops to give an effective speed of ISO 1600. Such adjustments are not possible with negative films or with Kodachrome.

◀ **You can alter the composition** after the printing stage by creative cropping. Here, I found that the llama competed for attention with its owner, so I cropped the horizontal enlargment to a square to yield the image below. Don't use scissors for this — you'll find it difficult to obtain a perfectly straight line. Instead use a sharp craft knife and very carefully cut along a steel straight edge.

◀ **Colors of prints** can be altered at the press of a button. This subway has a green cast, created by the fluorescent lights. Had I wished to restore natural hues, I could have told the lab that the film was exposed in fluorescent light and asked for a correction to minimize the anticipated color cast.
However, this flexibility can be a mixed blessing. When nothing in the negative suggests the colors of the original scene, the printer has to make a guess — and the colors in the print may not be faithful to what you saw.

▶ **When ordering reprints,** take along the original print and either ask for a color match or indicate how you prefer the print to look. For this landscape, I asked for a little more red to warm up the scene. Remember that color changes will affect the whole print, not just part of it.

SORTING YOUR PHOTOGRAPHS

An essential task when your film comes back from processing is to select the best pictures to keep and show. The first and easiest step is to weed out pictures with obvious faults, such as camera shake or incorrect exposure. Don't hoard your mistakes, but on the other hand do think twice before you throw away – an "error" may accidentally add to the impact or atmosphere of an image. Next, sort the pictures into categories. Keep an open mind about this, as unexpected groupings may suggest themselves – for example, a series of architectural close-ups that share similar color schemes. Finally, caption all pictures succinctly.

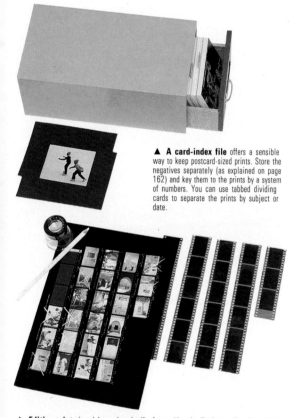

▲ **A card-index file** offers a sensible way to keep postcard-sized prints. Store the negatives separately (as explained on page 162) and key them to the prints by a system of numbers. You can use tabbed dividing cards to separate the prints by subject or date.

▲ **Editing prints** is quicker and easier if you have a few simple tools. Cheapest of all is a pair of cardboard masks cut to L-shapes. You can use these to try out various crops on a print without marking or cutting. Remove flat areas of sky or irrelevant details at the edges of the picture. Once you've decided on the crop that seems to work most successfully, you can order an enlargement to the size you want. A wax pencil is handy for marking the final crop; it writes clearly on the glossy surface of a print but the wax marks can be easily removed with a little turpentine. If you have contact sheets made, always examine them in conjunction with the negatives: although they have the advantage of showing every frame on the roll, contact sheets can hide detail that's plainly visible on negatives.

156

Captions and labels

Label your photographs as soon as they come back from the lab: otherwise, you will be surprised how soon the places you visited blend into a pleasant but frustratingly vague memory. Either use detailed captions or number each picture to correspond with your notes. Use a special marker to write on the back of a print or on a plastic mount — marks from most other pens will rub off. Some people, however, prefer stick-on labels. If you took a lot of pictures that require the same title, it's worth investing in an office printing outfit with movable rubber letters, so that you can stamp captions on labels quickly and easily. A useful trick with slides is to mark the left-hand upper corner of each with a colored adhesive dot, so that you know which way round they should go in the projector.

▲ **Editing slides** becomes much easier if you use a lightbox: on a screen or in a viewer you can see only one picture at a time, whereas on a lightbox side-by-side comparisons are easier. Purpose-built models are expensive, especially if color-corrected to daylight. However, you can make do with a sheet of glass propped between two chairs: tape tracing paper beneath the glass, and light it from below with a table lamp. You will need a good 4 × or 8 × magnifier: avoid cheap ones with plastic lenses, as these tend to hide faults. Handle the slides carefully by their edges, particularly if they are unmounted. Every fingermark or scratch will show up all too clearly on a projected image or print made from the slide. For maximum protection use individual plastic sleeves or mounts with glass covers.

ARRANGING A SLIDE SHOW

A successful slide show depends on planning, with the images projected in a logical sequence. The method may be chronological, geographical or thematic. If you choose the narrative approach, it helps to start thinking about the show even at the picture-taking stage. To preserve continuity in the story, shoot all key events, including packing and arriving at the hotel. Don't just photograph the good times: minor disasters may seem amusing in retrospect and make good anecdotes. If your pictures were more erratically taken, a geographical approach will be easiest to organize. Rambling commentaries will lose your audience's sympathy, so follow a script. Keep the session brief: 15 minutes is a sensible maximum. Plan to keep most slides on screen for less than 10 seconds, but vary the pace – perhaps with one or two rapid close-ups after a lingering broad view.

▲ **Slide projectors** range from manual push-and-pull fixed-focus models to the Carousel (top right), which has a rotary tray for 80 slides, plus remote slide-changing and focusing. Some models change slides automatically according to a preset program. When buying a projector, pay particular attention to lens quality. Handheld viewers (above) are space-saving and can be used without darkening the room, but only one person at a time can see the picture. More convenient is the daylight projector (right), which can be used by a small group and has magazine slide-changing.

▲ **Add professional polish** to your slide show by using a recorded commentary and slide synchronizer which will change slides at programmed moments in the narrative. You may even want to take a tape cassette recorder on your travels to record live music or sound effects. A second projector, or a twin-lens model like the one illustrated above, enables you to dissolve smoothly from one image to the next.

▶ **Borrow techniques from the movies** to make your slide show smoothly professional. In the sequence illustrated opposite, taken in Bali, I started with an establishing shot (top), then moved in to give viewers a general idea of the islanders' lifestyle (middle) and finally came in close for human interest (bottom). When changing to a new scene or subject, try to find some kind of linking image. First and foremost, you must keep all your pictures horizontal: switching to an upright format and back will be visually disruptive. To save the trouble of making title slides, take pictures of placename signs while you are traveling. Signs such as ''To the beach'' can help in the telling of a narrative. A sunset or a view of a train or other vehicle disappearing into the distance makes an effective ending. If you use a musical soundtrack, fade it out gradually as the show finishes.

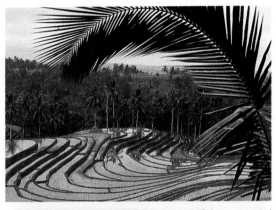

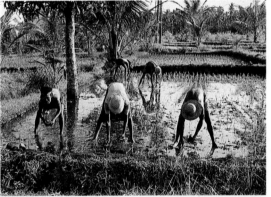

DISPLAYING YOUR PRINTS

There are numerous ways to put your prints on display, all of them offering plenty of scope for an imaginative approach. You can turn a vacation album into a kind of mini publishing project – an organized collection of visual impressions with back-up information that may be as detailed or as succinct as you wish. Alternatively, you can have enlargements made for a wall display – either framed or fixed on mounting board (using double-sided tape, photographic adhesive or a sandwich of special "dry mounting" tissue which forms a bond when heat and pressure are applied). A window mount, showing your print behind a recessed cutout, will impart a sense of depth to the image, although borderless block mounts are equally popular. Other ideas are to exhibit a group of prints on a standing folder for a shelf or table display, or on individual cards kept as a set in a suitably sized portfolio box. When considering whether a picture merits individual presentation, ask yourself whether it needs a brief explanation to give it maximum impact; if so, perhaps the image is better suited to an album display, grouped together with different views of the same subject, with accompanying captions. Don't regard the standard picture formats as sacrosanct: use a craft knife and metal straight-edge to crop out unnecessary details and strengthen the composition.

▲ **Protect individual prints** by slipping them into windowed cardboard wallets (top left). These are useful for temporary displays. They keep prints clean and prevent the edges from being damaged. Just as important, a folder keeps the light out when the picture is not on view: most color prints fade quickly in bright light, whereas storage in a dark place will keep the hues looking fresher.

▲ **Album layouts** should vary from page to page. Use different-sized enlargments to vary the pace. If you wish, you can stick in other mementoes, such as transport or entrance tickets to identify the location. Highlight special prints or groups of prints by drawing box rules around them. As an alternative to the ready-made albums shown above, it is rewarding to make your own using raw materials from an art supplier.

Print mounting

Before using an adhesive to mount a print, check that it won't accelerate fading or color change. Avoid any glue that contains formaldehyde. Rubber cement is safe, but you must apply it in a very thin layer to both mount and print and allow to dry before making the contact; otherwise the print will peel up. With other adhesives, follow manufacturers' instructions carefully. Avoid water-based glues, such as wallpaper paste: prints contain a plastic layer that prevents drying. Adhesive leaves marks if it seeps outside the picture area onto the mount border, so you may prefer double-sided tape. For temporary mounting, look for "low-tack" glues or use traditional-style photo-corners.

▶ **Simple mounts** are easy to make at home. Buy mounting board in a color that complements the image and fix down the print with adhesive. To protect the surface, cover with self-adhesive plastic film. For the neatest results, use a piece of board bigger than the print, then trim off the excess after mounting – either flush with the print's edge or leaving a broad border.

▶ **Clip-frames** offer an inexpensive way to produce professional-looking mounted prints. The print is positioned between a glass sheet and an equal-sized hardboard backing, and the three layers are held firmly together by unobtrusive chrome-faced clips. If you prefer a more versatile approach, you can buy the clips separately from a framing supplier and have your glass and boards cut to any desired size to suit the type of display you have in mind.

▶ **Aluminum channel frames** are more expensive, but make elegant modern settings. The usual approach is to buy lengths of extruded aluminum ready-cut with chamfered corners. Special L-shaped brackets are used to join up the lengths. Glass and backing board must be specially cut to the right size. Small spring clips hold the print, the board and the glass tightly together.

▶ **Custom-made frames** offer the greatest variety of finishes and colors, but they tend to be costly. Simple styles are best. Avoid frames that are over-elaborate. Many framers offer the option of non-reflective glass (which is especially useful for walls opposite windows), but beware: the etched surface of the glass absorbs a lot of light, so it is preferable to use lighter than normal prints.

STORING NEGATIVES AND SLIDES

If prints are accidentally lost, damaged or destroyed, they can be re-created without too much trouble. But if such a misfortune befalls your transparencies or negatives, there is no way to get them back. The uniqueness of your originals makes it crucial to store them safely. Properly processed and carefully kept, most of today's films will suffer only negligible color changes during your lifetime. However, an original that is exposed to unsympathetic conditions may deteriorate inside a year. Store both slides and negatives in a cool, dry place, away from dust or fumes from heating appliances. The temperature should be kept below 60°F (15°C). Silica gel sachets are a useful safeguard against excessive humidity.

Accessibility is another important factor. The best filing system to use will depend on how prolific a photographer you are, and on the number of pictures you have accumulated from previous trips. If you take only two rolls of film while away, you will have no retrieval problems, even if your storage is unsystematic – but as your collection builds up, you will need to introduce a more organized method. If you take 10 rolls on one trip, meticulous filing immediately becomes imperative: looking at every picture to find the specific one you want would be a major chore.

▲ **Negatives** will not need to be searched out as often as slides: you will only need to look for specific images when new prints are required. The first rule is never to cut strips of negatives into individual frames, as this makes them difficult to print. Instead, store strips in clear or translucent sleeves. Don't put more than one strip in a sleeve, or trapped dust may cause scratches. A good way to store the sleeves is in drawered cabinets of the kind used for index cards. Use cards to divide one strip from the next, and to write captions on. If you have contact sheets made from your negatives, you may find it easier to store the negatives in special protective sheets in a loose-leaf ring binder; you can then punch holes in the contact sheets and keep these alongside the negatives for ready visual reference.

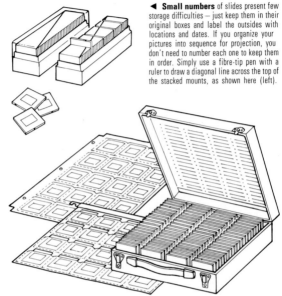

◀ **Small numbers** of slides present few storage difficulties — just keep them in their original boxes and label the outsides with locations and dates. If you organize your pictures into sequence for projection, you don't need to number each one to keep them in order. Simply use a fibre-tip pen with a ruler to draw a diagonal line across the top of the stacked mounts, as shown here (left).

▲ **A slide file** helps you to keep track of large numbers of transparencies. The professional approach is to use clear plastic file pages, which hold 20 or 24 mounted slides, each in an individual pocket, as shown above. The back of each file sheet is frosted, so by holding it up to the light you can locate at a glance the image you want.

Some file sheets are punched for a ring binder; others have suspension bars that fit into ordinary office filing cabinets. For long-term storage of pictures that you rarely look at, wooden or metal boxes with individual slots for each slide (as shown in the illustration above) may be a more convenient choice.

▲ **Prepared slide shows** need to stay in a particular sequence which rarely, if ever, changes. The simplest answer is to keep the slides in the magazine that you use for projection — but bear in mind that spare magazines for some types of projector are expensive. You must take care to store the magazine itself in a dust-free environment, or your projected pictures will gradually become spoilt by black specks. Circular

magazines are best for storage purposes, because they are sealed from dust by a cover on top and a circular metal plate underneath. For straight magazines, special dustproof storage boxes are a worthwhile investment. Don't be tempted to put the magazines in plastic bags, however: this can cause condensation, which in turn can encourage the growth of emulsion-damaging fungus on the slides.

I need a film — **for this camera**
J'ai besoin d'un film — pour cet appareil-photo
zhay buh-zwañ duñ feelm — poor set a-pa-ray-fö-tò

I want — **35 mm black-and-white film**
Je voudrais — une pellicule noir et blanc 24 x 35
zhuh voo-dreh — ōōn peh-lee-kōōl nwar ay bloñ
vañ-ka-truh troñt sañk

— **fast/slow film**
— un film rapide/lent
— un feelm ra-peed/loñ

— **color print film**
— une pellicule couleur sur papier
— ōōn peh-lee-kōōl koo-lur sōōr pap-yay

— **color slide film**
— une pellicule couleur pour diapositives
— ōōn peh-lee-kōōl koo-lur poor
dee-a-po-zee-teey

— **batteries for the flash**
— des piles pour le flash
— dey peel poor luh flash

Can you develop this film, please?
Est-ce que vous pouvez développer ce film, s'il vous plait?
es kuh voo poo-vay day-vuh-lo-pay suh feelm, seel voo pleh

When will the photographs be ready?
Quand est-ce que les photos seront prêtes?
koñ tes kuh lay fö-tò suh-roñ pret

There is something wrong with my camera
Mon appareil-photo marche mal
moñ na-pa-ray-fö-tò marsh mal

The film is jammed
Le film est bloqué dans l'appareil
luh feelm eh blo-kay doñ la-pa-ray

The shutter is jammed
L'obturateur ne march pas
Lop-tōō-ra-tur nuh marsh pa

I would like to buy a camera — **with single-lens reflex**
Je voudrais un appareil — reflex mono-objectif
zhuh voo-dreh zuñ na-pa-ray — ruh-fleks mo-nö-op-zhek-teef

— **with a built-in light meter**
— avec cellule incorporée
— a-vek seh-lōōl añ-kor-po-ray

— **for instant pictures**
— avec développement instantané
— a-vek day-vuh-lop-moñ añ-stoñ-ta-nay

I need — **a flash attachment**
Il me faut — un flash
eel muh fö — uñ flash

— **a telephoto/wide angle lens**
— un téléobjectif/un objectif grand angulaire
— uñ tay-lay-op-zhek-teef/uñ nop-zhek-teef
groñ toñ-gōō-lehr

— **a camera case**
— un boîtier
— uñ bwat-yay

— **a polarizing filter**
— un filtre polarisant
— uñ feel-truh po-la-ree-zoñ

Is one allowed to take photos — **with flash/tripod**
Est-ce qu'on peut prendre des photos — avec flash-trépied?
es koñ puh proñ-druh day fö-tò — a-vek flash/tray-pyah

I need a film — **for this camera**
Ich brauche einen Film — für diese Kamera
ikh brow·khè ine·èn film — fōōr dee·zè ka·mè·ra

I want — **a 35 mm black and white film**
Ich hätte gern — einen fünfunddreißig Millimeter
Schwarz-Weiß-Film
*ikh he·tè gern — ine·èn fōōnf·oont·drye·sikh
mi·lee·may·tèr shvarts·vice·film*

— **a fast/slow film**
— einen empfindlichen/unempfindlichen Film
— *ine·èn emp·fint·li·khèn/
oon·emp·fint·li·khèn film*

— **a color print film**
— einen Farbfilm
— *ine·èn farp·film*

— **a color slide film**
— einen Diafarbfilm
— *ine·èn dee·a·farp·film*

I want — **batteries for the flash**
Ich hätte gern — Batterien für das Blitzgerät
ikh he·tè gern — ba·tè·ree·èn fōōr dass blits·gè·ret

Can you develop this film, please?
Würden Sie bitte diesen Film entwickeln?
vōōr·dèn zee bi·tè dee·zèn film ent·vi·kèln

When will the photographs be ready?
Wann sind die Bilder fertig?
van zint dee bil·dèr fer·tikh

There is something wrong with my camera
Mit meiner Kamera stimmt etwas nicht
mit mine·èr ka·mè·ra shtimt et·vass nikht

The film is jammed
Der Film klemmt
der film klemt

The shutter is jammed
Der Verschluß klemmt
der fer·shlooss klemt

I would like to buy a single lens reflex camera
Ich möchte gern eine Spiegelreflex-Kamera
ikh mur'kh·tè gern ine·è shpee·gèl·ray·fleks·ka·mè·ra

I would like to buy a camera with a built-in light meter
Ich möchte gern eine Kamera mit eingebautem Belichtungsmesser
ikh mur'kh·tè gern ine·è ka·mè·ra mit ine·gè·bow·tèm bè·likh·toongs·me·sèr

I would like to buy an instant camera
Ich möchte gern eine Sofortbildkamera
ikh mur'kh·tè gern ine·è zō·fort·bilt·ka·mè·ra

I need — **a flash attachment**
Ich brauche — ein Blitzgerät
ikh brow·khè — ine blits·gè·ret

— **a telephoto/wide-angle lens**
— ein Teleobjektiv/ein Weitwinkelobjektiv
— *ine tay·lay·op·yek·teef/ine
vite·ving·kèl·op·yek·teef*

— **a camera case**
— ein Kameratasche
— *ine·è ka·mè·ra·ta·shè*

— **a polarizing filter**
— ein Polarisationsfilter
— *ine po·la·ree·zat·zee·onz·fil·tèr*

Is one allowed to take photos with a flash/tripod?
Darf man mit Blitzlicht/Stativ fotografieren?
darf man mit blits·likht/shta·teef fō·tò·gra·fee·rèn

I need a film — for this camera
Necesito una película — para esta cámara
ne·the·**see**·to oo·na
pe·**lee**·koo·la — **pa**·ra es·ta ka·ma·ra

I want — 35 mm black and white film
Quiero — un carrete de 35 mm en blanco y negro
kye·ro — oon ka·**rre**·te de **treyn**·ta ee **theen**·ko
mee·lee·**me**·tros en **blan**·ko ee **ne**·gro

— fast/slow film
— una película rápida/lenta
— **oo**·na pe·**lee**·koo·la **ra**·pee·da/**len**·ta

I want — a color print film
Quiero — una película en color
kye·ro — oo·na pe·**lee**·koo·la en ko·**lor**

— a color slide film
— una película de diapositivas en color
— **oo**·na pe·**lee**·koo·la de
dee·a·po·see·**tee**·bas en ko·**lor**

— batteries for the flash
— pilas para el flash
— **pee**·las **pa**·ra el flash

Can you develop this film, please?
¿Puede revelar esta película, por favor?
pwe·de re·be·**lar es**·ta pe·**lee**·koo·la por fa·**bor**

When will the photographs be ready?
¿Para cuándo estarán las fotos?
pa·ra **kwan**·do es·ta·**ran** las **fo**·tos

There is something wrong with my camera
Mi cámara fotográfica no va bien
mee **ka**·ma·ra fo·to·**gra**·fee·ka no ba byen

The film is jammed
La película está atascada
la pe·**lee**·koo·la es·**ta** a·tas·**ka**·da

The shutter is jammed
El obturador está atascada
el ob·too·ra·**dor** es·**ta** a·tas·**ka**·da

I would like to buy a camera with — a single-lens reflex
Quisiera comprar una cámara — reflex
kee·**sye**·ra kom·**prar** oo·na ka·ma·ra — re·**fleks**

— built-in light meter
— con exposímetro incorporado
— kon eks·po·**see**·me·tro een·kor·po·**ra**·do

— for instant film
— con revelado instantáneo
— kon re·be·**la**·do eens·tan·**ta**·neo

I need a — flash attachment
Necesito — un aparato de flash
ne·the·**see**·to — oon a·pa·**ra**·to de flash

— telephoto/wide-angle lens
— objetivo de primer plano/gran angular
— ob·khe·**tee**·bo de pree·**mer pla**·no/
gran an·goo·**lar**

— camera case
— una funda para la máquina
— **oo**·na **foon**·da pa·ra la **ma**·kee·na

— a polarizing filter
— un filtro polarizador
— oon **feel**·tro po·la·ree·tha·dor

Is one allowed to take photos — with flash/tripod
¿Se pueden hacer fotos — con flash/trípode?
se **pwe**·den a·**ther fo**·tos — kon flash/**tree**·po·de

I need a film — for this camera
Ho bisogno di una pellicola — per questa macchina fotografica
o bee-zoh-nyoh dee oo-na pel-lee-ko-la — payr kway-sta mak-kee-na
fo-to-gra-fee-ka

I want — a black and white film
Vorrei — una pellicola in bianco e nero
vor-rey — oo-na pel-lee-ko-la een byan-ko e nay-ro

— a fast/slow film
— una pellicola rapida/lente
— oo-na pel-lee-ko-la ra-pee-da/len-ta

I want — a color print film
Vorrei — una pellicola a colori
vor-rey — oo-na pel-lee-ko-la a ko-loh-ree

— a color slide film
— una pellicola a colori per diapositive
— oo-na pel-lee-ko-la a ko-loh-ree payr
dee-a-po-zee-tee-ve

— batteries for the flash
— delle batterie per il flash
— del-le bat-te-ree-e payr eel flash

Can you develop this film please?
Può sviluppare questa pellicola per favore?
pwo zvee-loop-pah-ray kway-sta pel-lee-ko-la payr fa-voh-re
When will the photographs be ready?
Quando saranno pronte le foto?
kwan-do sa-ran-no prohn-te le fo-toh
There is something wrong with my camera
C'è qualcosa che non va nella mia macchina fotografica
che kwal-ko-sa ke nohn va nel-la mee-a mak-kee-na fo-to-gra-fee-ka
The film is jammed
La pellicola è bloccata
la pel-lee-ko-la e blok-kah-ta
The shutter has something wrong with it
L'otturatore hanno un difetto
lot-too-ra-toh-re an-no oon dee-fet-toh

I would like to buy a camera — with single-lens reflex
Vorrei comprare una macchina fotografica — con obiettivo semplice reflex
vor-rey kom-prah-ray oo-na — kohn o-byet-tee-voh saym-plee-che
mak-kee-na fo-to-gra-fee-ka ree-fleks

I would like to buy a camera — with built-in light meter
Vorrei comprare una macchina fotografica — con esposimetro incorporato
vor-rey kom-prah-rey oo-na — kohn e-spo-zee-me-troh
mak-kee-na fo-to-gra-fee-ka een-kor-po-rah-to

— for instant pictures
— con sviluppo istantaneo
— kohn zvee-loop-poh ee-stan-tah-ne-o

I need — a flash attachment
Ho bisogno di — un flash
o bee-zoh-nyoh dee — oon flash

— a telephoto/wide-angle lens
— un obiettivo per primi piani/obiettivo
grandangolare
— oon o-byet-tee-voh payr pree-mee
pyah-nee/o-byet-tee-voh
gran-dan-go-lah-re

— a camera case
— una custodia da macchina fotografica
— oo-na koo-sto-dya da
mak-kee-na fo-to-gra-fee-ka

— a polarizing filter
— un filtro polarizzatore
— oon feel-troh po-la-reets-tsa-toh-ray

Is one allowed to take photos with a flash/tripod?
Si possono fare delle fotografie con il flash/treppiedi?
see pos-so-no fah-ray del-le fo-to-gra-fee-e kohn eel flash/trep-pye-dee

167

GLOSSARY

Aerial perspective An effect of depth in a picture created by haze in the atmosphere, causing distant parts of a landscape to appear blue and softened.

Aperture Strictly, the opening that limits the amount of light reaching the film and hence the brightness of the image. In some cameras the aperture is of a fixed size; in others it is in the form of an opening in a barrier called the DIAPHRAGM and can be varied in size. Photographers, however, generally use the term 'aperture' to refer to the diameter of this opening. See also F-NUMBER.

ASA .American Standards Association, which devised one of the two most commonly used systems for rating the speed of an emulsion (i.e., its sensitivity). A film rated at 400 ASA would be twice as fast as one rated at 200 ASA and four times as fast as one rated at 100 ASA. See also DIN, ISO.

Automatic camera Camera that automatically sets the correct exposure by a link between the exposure meter and the shutter or aperture diaphragm or both. There are three main types: aperture priority (the most popular), when the photographer sets the aperture and the camera selects the appropriate speed; shutter priority, when the photographer chooses the speed and the camera sets the correct aperture; and programmed, when the camera sets both aperture and shutter speed. Multi-mode cameras can be set to aperture or shutter priority, and, in some models, programmed.

Available light Term used to describe existing light, without the introduction of any supplementary light by the photographer. Usually it refers to low illumination levels, for example indoors or at night.

Backlighting Lighting, natural or artificial, from behind the subject of a photograph.

Ball-and-socket head Type of tripod fitting that allows the camera to be secured at the required angle by fastening a single locking-screw.

Bounced flash Soft light achieved by aiming flash at a wall or ceiling to avoid the harsh shadows that result if the light is pointed directly at the subject.

Bracketing Technique of ensuring optimum exposure by taking several identical pictures of the same subject at slightly different exposure settings.

B setting Setting of the shutter speed dial of a camera at which the shutter remains open while the release button is held down.

Cable release Simple camera accessory used to reduce camera vibrations when the shutter is released, particularly when the camera is supported by a tripod and a relatively long exposure is being used. It consists of a short length of thin cable attached at one end to the shutter release of the camera; the cable is encased in a flexible rubber or metal tube and is operated by a plunger.

Camera shake Accidental movement of the camera during exposure, resulting in overall blurring of the image.

Cast Overall shift towards a particular hue, giving color photographs an unnatural appearance.

Center-weighted meter Type of through-the-lens light meter. The reading is most strongly influenced by the intensity of light at the center of the image.

Color compensating filters Filters designated by the letters CC and used to alter the color balance of a slide, particularly to compensate for a color bias in the light source.

Color conversion filters Filters used to adjust the color balance of a light source when it differs substantially from the color temperature for which a film type is designed. Such filters can convert tungsten slide film into daylight film or vice versa.

Color correction filters (or light balancing filters). Comparatively weak color filters used to correct for small differences between the color temperature of the illumination used for a particular exposure and that for which the film was manufactured. An 85B filter is used with tungsten film in daylight, an 80A filter with daylight film in tungsten light.

Color negative (print) film Film yielding color negatives intended for printing.

Color reversal film Film yielding color positives (i.e., slides or transparencies) directly. Prints can also be made from the positive transparencies.

Color temperature Measure of the relative blueness or redness of a light source, expressed in KELVINS.

Complementary colors Two contrasting colors that produce an achromatic shade (white, gray or black) when mixed.

Contact print Print which is the same size as the negative, made by sandwiching together the negative and the photographic paper when making the print.

Contrast Degree of difference between the lightest and darkest parts of a subject, negative, print or slide.

Converter See TELECONVERTER.

Cropping Enlarging only a selected portion of the negative.

Daylight film Color film balanced to give accurate color rendering in average daylight. Also suitable for use with flash.

Dedicated flash Flash unit made for one specific model or range of cameras to enable light output, aperture and shutter speed to be synchronized perfectly.

Depth of field Zone of acceptable sharpness extending in front of and behind the point on the subject which is exactly focused by the lens. Depth of field varies with (1) the distance of the point focused from the lens (the shorter the distance, the more shallow the depth of field); (2) the size of the aperture (the smaller the aperture, the greater the depth of field); (3) the focal length of the lens (the greater the focal length, the shallower the depth of field).

Diaphragm System of adjustable metal blades forming a roughly circular opening of variable diameter, used to control the APERTURE of a lens.

Diffusion Scattering of light when it is transmitted through a translucent but not transparent medium, (tracing paper, for example). Diffusion has the effect of eliminating glare and harsh shadows.

DIN Deutsche Industrie Norm, the German standards association, which devised one of the widely used systems for rating the speed of an emulsion (see also ASA and ISO). 21 DIN is equivalent to 100 ISO.

Electronic flash Type of flashgun which uses the flash of light produced by a high-voltage electrical discharge between two electrodes in a gas-filled tube.

Emulsion In photography, the light-sensitive layer of a photographic material.

Enlargement Photographic print larger than the original image on the film. See also CONTACT PRINT.

Exposure Total amount of light allowed to reach the light-sensitive material during the formation of the LATENT IMAGE. The exposure is dependent on the brightness of the image, the camera APERTURE and on the length of time for which the photographic material is exposed.

Exposure latitude Tolerance of photographic material to variations in exposure.

GLOSSARY

Exposure meter Instrument for measuring the intensity of light so as to determine the correct SHUTTER and APERTURE settings. The basic principle is that of light energizing a photosensitive cell to produce a current that actuates a pointer or LEDS.

Extension tubes Accessories used in close-up photography, consisting of metal tubes that can be fitted between lens and camera body, thus increasing the lens-to-film distance.

Fast lens Lens of wide maximum aperture, relative to its focal length.

Fill-in-light Additional lighting used to supplement the principal light source and brighten shadows.

Film speed A film's degree of sensitivity to light. Usually expressed as a rating on the ISO, ASA or the DIN scales.

Filter Transparent sheet, usually of glass or gelatin, used to block a specific part of the light passing through it, or to change or distort the image in some way. See also COLOR CONVERSION FILTERS, COLOR CORRECTION FILTERS and POLARIZING FILTERS.

Flare Light reflected inside the camera or between the elements of the lens, giving rise to irregular marks on the negative and degrading the quality of the image.

F-number Number resulting when the focal length of a lens is divided by the diameter of the aperture. A sequence of f-numbers, marked on the ring or dial which controls the diaphragm, is used to calibrate the aperture in regular steps (known as STOPS) between its smallest and largest settings. The f-numbers generally follow a standard sequence such that the interval between one stop and the next represents a halving or doubling in the image brightness. As f-numbers represent fractions, the numbers become progressively higher as the aperture is reduced to allow in less light.

Focal length Distance between the optical centre of a lens and the point at which rays of light parallel to the optical axis are brought to a focus.

Focal-plane shutter One of the two main types of shutter, used almost universally in SINGLE-LENS REFLEX CAMERAS. Positioned behind the lens (though in fact slightly in front of the focal plane) the shutter consists of a system of cloth blinds or metal blades; when the camera is fired, a slit travels across the image area either vertically or horizontally.

Focusing screen Screen of glass or plastic mounted in a camera to allow viewing and focusing of the image that the lens forms.

Format The size or shape of a negative or print. The term generally refers to a particular film size (e.g., 35mm), but in its more general sense can mean simply whether a picture is upright (vertical) or longitudinal (horizontal).

Graduated filter A filter in which a clear and colored half gradually blend into each other. A graduated filter can be used, for example, to enliven a dull sky in a landscape photo without affecting the rest of the image.

Gray card Card of a standard reflectance, used to obtain average reflected-light exposure readings.

Guide number Number indicating the effective power of a flash unit. For a given film speed, the guide number divided by the distance between the flash and the subject gives the appropriate F-NUMBER.

High-key Containing predominantly light tones. See also LOW-KEY.

Highlights Brightest areas of the subject, or corresponding

areas of an image; in a negative these are areas of greatest density.

Hotshoe Accessory shoe on a camera which incorporates a live contact for firing a flashgun, thus eliminating the need for a separate socket.

Incident light reading A method of measuring the light that falls on a subject as distinct from the light that is reflected from it. To take this kind of reading, the exposure meter is pointed from the subject toward the camera.

ISO (International Standards Organization). System of rating emulsion speeds which is replacing ASA and DIN. ISO 100 corresponds to 100 ASA.

Kelvin (K) Unit of temperature in the SI system of units. The kelvin scale begins at absolute zero ($-273°C$) and uses degrees equal in magnitude to $1°C$. Kelvins are used in photography to express degrees of COLOR TEMPERATURE.

Latitude Ability of a film to record an image satisfactorily if exposure is not exactly correct. Black-and-white and color print films have more latitude than color transparency films, and fast films have greater latitude than slow ones.

LCD (Liquid crystal display). Electronic numerical indicator that displays shutter speeds and apertures in the viewfinder of certain SLR cameras, relating directly to the camera's exposure control.

LED (Light emitting diode). Solid state electrical component used as a glowing colored indicator inside a camera viewfinder or other photographic apparatus to provide a visual signal or warning indicator for various controls.

Lens hood Simple lens accessory, usually made of rubber or light metal, used to shield the lens from light coming from areas outside the field of view. Such light is the source of FLARE.

Light balancing filters See COLOR CORRECTION FILTERS.

Long-focus lens Lens of focal length greater than that of the STANDARD LENS for a given format. Long-focus lenses have a narrow field of view, and consequently make distant objects appear closer. See also TELEPHOTO LENS.

Low-key Containing predominantly dark tones. See also HIGH-KEY.

Macro lens Strictly, a lens capable of giving a 1:1 magnification ratio (a lifesize image); the term is generally used to describe any close-focusing lens.

Microprism Special type of focusing screen composed of a grid of tiny prisms, often incorporated into the viewing screens of SLR cameras. The microprism gives a fragmented appearance when the image is out of focus.

Mirror lens Long-focus lens of extremely compact design whose construction is based on a combination of lenses and curved mirrors.

Motordrive Battery-operated device that attaches to a camera and automatically advances the film and re-tensions the shutter after an exposure has been made.

Negative Image in which light tones are recorded as dark, and vice versa; in color negatives every color in the original subject is represented by its COMPLEMENTARY COLOR.

Neutral density (ND) filter Uniformly gray filter which reduces the brightness of an image without altering its color content. Used in conjunction with lenses that have no diaphragm to control the aperture (such as MIRROR LENSES), or when light is too bright for speed of film used.

Off-camera flash Small flash unit linked to the camera with an electrical lead. Off-camera flash enables you to create more varied lighting effects than does a flashgun fitted to the hotshoe.

Pan-and-tilt head Type of tripod head employing independent locking mechanisms for movement in two planes at right angles to each other.

Panning Technique of swinging the camera to follow a moving subject, used to convey the impression of speed.

Parallax Apparent displacement of an object brought about by a change of viewpoint. Parallax error, apparent in close-ups only, is the discrepancy between the image produced by the lens and the view seen through the viewfinder where viewfinder and taking lens are separate.

Polarizing filter Thin transparent filter used as a lens accessory to cut down reflections from certain shiny surfaces (notably glass and water) or to intensify the color of a blue sky. Polarizing filters are made of a material that will polarize light passing through it and which will also block a proportion of light that has already been polarized; rotating the filter will vary the proportion that is blocked.

Primary colors Blue, green and red – the colors of light that when mixed together equally make white light and that when mixed in various combinations can make any other color.

Pushing Technique of extending the development of a film so as to increase its effective speed or to improve contrast. Usually used after rating a film at a higher than normal speed.

Rangefinder Optical device for measuring distance, often coupled to the focusing mechanism of a camera lens.

Reflector Any surface capable of reflecting light; in photography, generally understood to mean sheets of white, gray or silvered material used to reflect light into shadow areas.

Reflex camera Generic name for types of camera whose viewing systems employ a mirror to reflect an image onto a screen.

Rimlighting Lighting arrangement in which the light comes from behind or above the subject, creating a bright rim of light around the outline.

Selective focusing Technique of using shallow DEPTH OF FIELD at a wide aperture setting to show parts of a scene in sharp focus while other parts are deliberately blurred.

Selenium cell One of the principal types of photo-electric cell used in light meters.

Shutter Camera mechanism which controls the duration of the exposure. The two principal types of shutter are BETWEEN-THE-LENS SHUTTERS and FOCAL-PLANE SHUTTERS.

Single-lens reflex (SLR) camera One of the most popular types of camera design. Its name derives from its viewfinder system, which enables the user to see the image produced by the same lens that is used for taking the photograph. A hinged mirror reflects this image onto a viewing screen, where the picture may be composed and focused; when the shutter is released, the mirror flips out of the light path while the film is being exposed.

Skylight filter A pale filter that helps to cut down the amount of blue light entering the camera. This attachment which is similar to a UV filter, is useful when photographing scenes containing a lot of sky.

Soft focus Deliberately diffused or blurred definition of an image, often used to create a dreamy, romantic look in portraiture.

Speed The sensitivity of an emulsion as measured on one of the various scales (see ASA, ISO and DIN); or the maximum aperture of which a given lens is capable.

Standard lens Lens of focal length approximately equal to the diagonal of the negative format for which it is intended. In the case of 35mm cameras the standard lens usually has a focal length in the range of 50-55mm, slightly greater than the actual diagonal of a full-frame negative (about 43mm).

Stop Alternative name for aperture setting or F-NUMBER.

Stopping down Colloquial term for reducing the aperture of the lens. See also STOP.

Sync lead Electrical lead used to link the camera to a flashgun for OFF-CAMERA FLASH.

Teleconverter Device that fits between a lens and camera body to increase the effective focal length of the lens and produce a magnified image. Teleconverters come in various 'strengths', typically ×2 or ×3.

Telephoto lens Strictly, a special type of LONG-FOCUS LENS, having an optical construction which consists of two lens groups. The front group acts as a converging system, while the rear group diverges the light rays. This construction results in the lens being physically shorter than its effective focal length.

Thyristor control Computer flash device used to conserve unspent energy and enable faster and more economical recycling of a flash unit.

Transparency A photograph viewed by transmitted, rather than reflected, light. When mounted in a rigid frame, the transparency is called a slide.

Tripod Three-legged camera support. The legs (usually collapsible) are hinged together at one end to a head to which the camera is attached.

T-setting Abbreviation of 'time' setting – a mark on some shutter controls. The T setting is used for long exposures when the photographer wishes to leave the camera with its shutter open. The first time the shutter release is pressed, the shutter opens; it remains open until the release is pressed a second time.

TTL (through-the-lens) meter. Built-in exposure meter which measures the intensity of light in the image produced by the main camera lens.

Tungsten light A common type of electric light for both household and photographic purposes. Tungsten light is warmer in color (more orange) than daylight or electronic flash, and with daylight-balanced slide film you must use a blue filter to reproduce colors accurately. Alternatively, you can use special tungsten-balanced slide film.

UV filter Filter used over the camera lens to absorb ultraviolet radiation, which is particularly prevalent on hazy days. A UV filter enables one to penetrate the haze to some extent.

Viewfinder Window or frame on a camera, showing the scene that will appear in the picture, and often incorporating a RANGEFINDER mechanism.

Wide-angle lens Lens of focal length shorter than that of a STANDARD LENS, with a wider angle of view.

Zoom lens Lens of variable FOCAL LENGTH whose focusing remains unchanged while its focal length is being altered. Zooming is accomplished by changing the relative positions of some of the elements within the lens. Most typically, zooms extend from wide-angle/standard (say, 28–50mm); moderate wide-angle to standard-moderate telephoto (35–70mm or 50-135mm); or moderate/long telephoto (80–200mm). Zooms are heavier and have smaller maximum apertures than ordinary lenses.

INDEX

Five enemies of peace inhabit

with us—avarice, ambition,

envy, anger, and pride; if

these were to be banished,

we should infallibly enjoy

perpetual peace.

—PETRARCH

DAILY BENDER

Want Some More?

Hit up our humor blog, The Daily Bender, to get your fill of all things funny—be it subversive, odd, offbeat, or just plain mean. The Bender editors are there to get you through the day and on your way to happy hour. Whether we're linking to the latest video that made us laugh or calling out (or bullshit on) whatever's happening, we've got what you need for a good laugh.

If you like our book, you'll love our blog. (And if you hated it, "man up" and tell us why.) Visit The Daily Bender for a shot of humor that'll serve you until the bartender can.

Sign up for our newsletter at
www.adamsmedia.com/blog/humor
and download our Top Ten Maxims No Man Should Live Without.

INDEX